LEICESTERSHIRE

LINCOLNSHIRE

THISTLETON

MARKET OVERTON

TEIGH

CLIPSHAM

WHISSENDINE

COTTESMORE

LANGHAM

EXTON

TICKENCOTE

BURLEY-ON-THE-HILL

RYHALL

OAKHAM

GREAT CASTERTON

EMPINGHAM

RUTLAND WATER
RESERVOIR

STAMFORD

EDITH WESTON

CAMBRIDGESHIRE

MANTON

NORTH LUFFENHAM

RIDLINGTON

WING

PRESTON

SOUTH LUFFENHAM

BELTON

MORCOTT

UPPINGHAM

BISBROOKE

BARROWDEN

STOKE DRY

LYDDINGTON

SEATON

EYEBROOK
RESERVOIR

CALDECOTT

NORTHAMPTONSHIRE

a year in the life of rutland

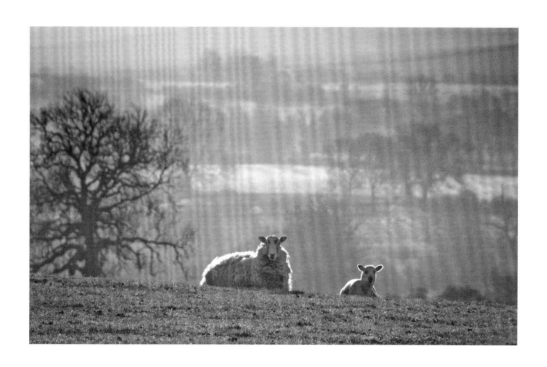

a year in the life of rutland derry brabbs

F

FRANCES LINCOLN LIMITED
PUBLISHERS

Frances Lincoln Limited
www.franceslincoln.com

A Year in the Life of Rutland
Copyright © Frances Lincoln Limited 2013
Text and photographs copyright © Derry Brabbs, 2013

First Frances Lincoln edition 2013

A catalogue record for this book is available from the
British Library.

978-0-7112-3286-0

Designed by Anne Wilson

Printed and bound in China

1 2 3 4 5 6 7 8 9

My thanks to :
Frances Lincoln and Anne Wilson for a superbly designed book;
Uppingham and Oakham Schools; Rutland Sailing Club;
Nigel Moon of Whissendine Windmill; Rutland County Council
(www.rutland.gov.uk/museum) for permission to photograph
Oakham Castle.

PAGE 1 Lambing time in Rutland.
PAGES 2–3 The dramatic view from the
A47 near Ayston, Uppingham.
THESE PAGES Rutland Water at sunrise.

contents

introduction

Small, but perfectly formed. Rutland has always been acknowledged as England's smallest county but the Isle of Wight is now generally cited as filling that role by just 2 or 3 square miles. This whole debate about the smallest county only materialised because although the Isle of Wight had originally been part of Hampshire, changes introduced by the Local Government Commission for England in 1997 elevated it to a unitary authority and hence a county in its own right. That same review fortunately reinstated Rutland's independency, having previously obliterated it from the map of England when the county was incorporated into Leicestershire under the Local Government Act of 1972. To say that Rutlanders were aggrieved by Whitehall's perceived meddling would be something of an understatement and even though their status quo had been re-established, it took another decade of campaigning to then persuade the Royal Mail to acknowledge the change and create a postal county of Rutland. Even more bizarrely, the English county with the smallest land mass was chosen as the most suitable location for a giant reservoir that, at the time of its creation in the 1970s, was one of Europe's largest manmade lakes!

BELOW Rutland Water has evolved into one of England's most significant wildfowl reserves, regularly holding up to 20,000 birds at any given time and also hosts the country's largest Osprey colony. The Rutland Water Nature Reserve occupies 9 miles of the shoreline along the western end of the reservoir and a further initiative, the Rutland Water Habitats Project, came to fruition in 2011, extending the area covered by the Reserve to 1,000 acres.

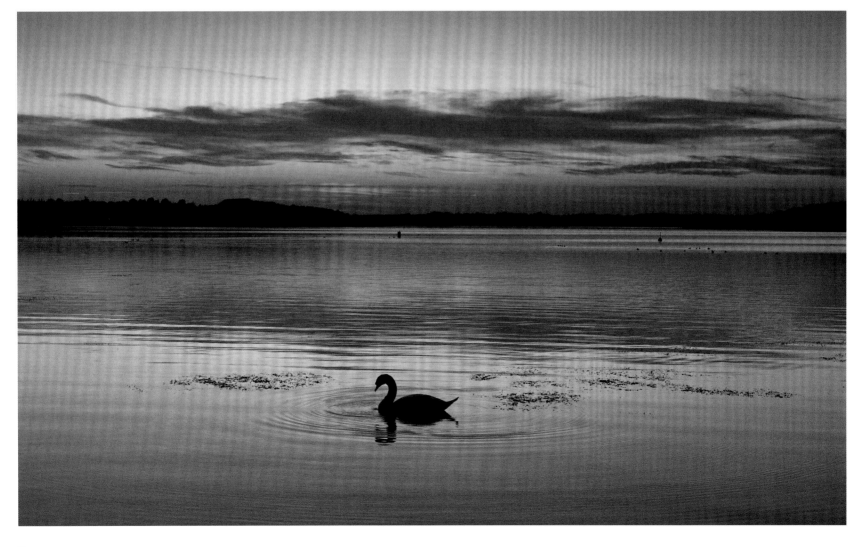

Encompassed within Rutland's 150 square miles is a treasured slice of quintessential England and although it could be deemed slightly patronising to suggest that 'time has stood still' here, the fact remains that Rutland's landscape, its two towns and over fifty villages have thus far largely escaped from the wholesale development and environmentally insensitive planning that has blighted so many other counties. Rutland is obviously not exempt from current government directives regarding the need for additional housing simply because of its diminutive size but equally, has neither the space, infrastructure nor the necessary services to cater for major population surges. The county's two towns, Oakham and Uppingham have made provision for expansion within their respective Local Plans, but any increases will surely have to be capped at realistic levels.

Rutland is bordered by Leicestershire to the west, Lincolnshire to the east and north and Northamptonshire to the south, the latter boundary marked along its entire length by the River Welland, the most significant of the county's four rivers. The other three, the Chater, Gwash and the Eyebrook are all tributaries of the Welland and their combined waters eventually flow into the Wash near Spalding. Rutland's countryside is surprisingly varied and as with most of England, the landscape character of any given place is largely determined by its geology. The area is underlain by deposits laid down in the warm, shallow tropical seas that prevailed during the Jurassic Age between 150 and 200 million years ago and the resulting limestone lies at various depths beneath layers of heavier clay. A band of limestone runs diagonally from the Yorkshire coast to Dorset, endowing each county, city, town or village above its path with a rich source of the finest quality building stone. The palette of colours manifested in Rutlands' buildings ranges from the neutral shades normally associated with limestone to the vibrant gold and browns of the ironstone that predominates further west towards Northamptonshire.

From the Welland Valley in the south, the ground gradually rises up to a plateau whose summit is at 600 feet above sea level and tilts eastwards towards Lincolnshire and the Fens. The rivers rise amidst the highest parts of the plateau across the Leicestershire border, thereafter draining to the south and east and in the process, flowing through surprisingly wide river valleys whose proportions somehow seem at odds with the streams that carved them out over eons of time. Up on the higher reaches of the plateau, there are far reaching views out across an undulating landscape of rich arable land dotted with wooded copses and one can readily appreciate why this area was particularly prized as a hunting forest by the Norman kings and remained so for many centuries thereafter. The great Leighfield Forest

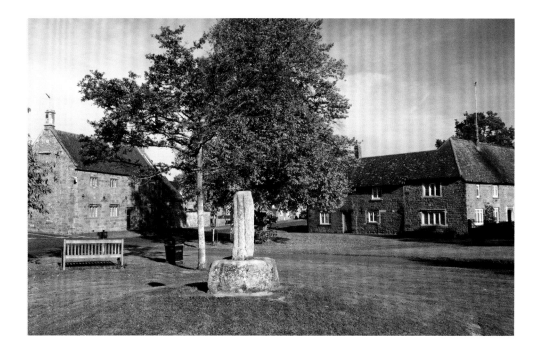

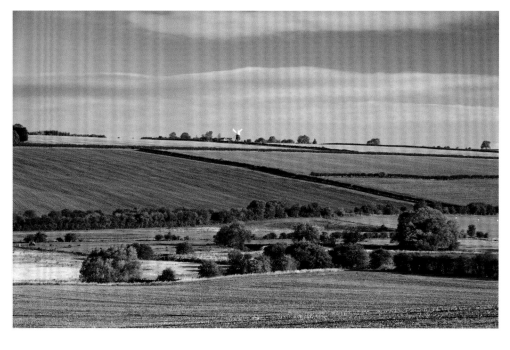

BELOW The fifteenth century market cross on Lyddington village green.

BOTTOM Rutland's countryside is a visual treat in autumn when stripped of its summer mantles of green and gold. Standing on a ridge near Barrowden, this restored windmill was first mentioned in fifteenth century parish records.

straddling the boundary between Leicestershire and Rutland was part of that medieval hunting forest and although still containing numerous clusters of ancient woodlands, they have become increasingly isolated from one another through farming activities and hedgerow removal.

Most of the English counties were already established at the time of the Norman Conquest but Rutland was sparsely populated and still heavily forested. Many Rutland villages such as Belton, Exton, Langham, Manton and others are all typical of the ring-fence type of forest settlement in which three or four roads enclose a piece of land. Significant parts of Rutland (known then as Roteland) were certainly owned by a succession of Saxon kings and it is recorded that the greatest of those, Edward the Confessor, bestowed them upon his queen, Edith. That royal link is remembered in the naming of the village, Edith Weston and a faded medieval wall painting of the Confessor survives in the church of St Andrew, Lyddington.

The creation of the barony of Oakham was a significant event in the county's history and one of the earliest holders of that title between 1166–99, Walchelin de Ferrers, was responsible for building Oakham Castle, whose great hall is one the finest surviving examples of Norman domestic architecture anywhere in England. Some two centuries later, the Earldom of Rutland was created for Edward Plantaganet (1373–1415) but the title subsequently fell out of use until its second creation in 1525 when Thomas Manners (1488–1543) became the 1st Earl of Rutland. Successive generations of the Manners family held the title until 1703 when John Manners, the 9th Earl was created 1st Duke of Rutland by Queen Anne and the earldom thereafter incorporated into that elevation to the peerage. The family seat of the Dukes of Rutland is Belvoir Castle, a magnificent building set in an estate of 15,000 acres located 10 miles north of the county boundary near Grantham, Lincolnshire. It is the fourth castle to have occupied the site since Norman times and the current version was built in the nineteenth century after a disastrous fire all but destroyed the third castle. Most of Belvoir Castle is open to the public but is nevertheless still home to the Manners family, maintaining an impressive continuity stretching back over five centuries.

Rutland is famous for its large houses and estates and

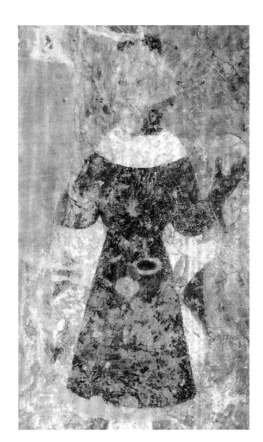

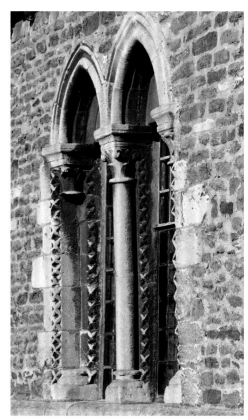

TOP LEFT A medieval wall painting in St Andrew's, Lyddington, is believed to be of Edward the Confessor, King of England from 1042 until his death in 1066. The village of Edith Weston is named after his wife, Edith, who inherited his vast land holdings in Rutland.

TOP RIGHT The windows of the great hall of Oakham Castle bear the distinctive decorative features of Norman architecture that one would normally expect to now only see in churches.

ABOVE Many of Rutland's villages have attractive, modestly sized greens but Exton's is a vast quadrangle of grass almost completely shaded by the foliage of its many mature trees.

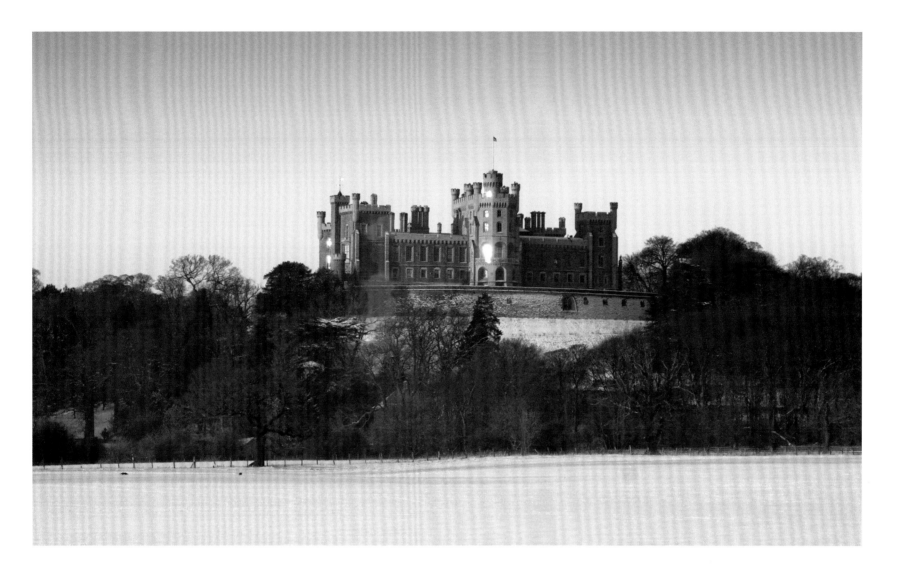

although some of the mansions erected by wealthy landowners have disappeared, their legacy remains through the many acres of landscaped parkland laid out in the eighteenth century. This small county is also renowned for possessing a seemingly disproportionate number of impressive medieval Gothic churches built and endowed by its most influential families. Inside several of those churches are housed remarkable tombs and monuments, with Exton widely acknowledged as being one of the best collections of funerary sculpture in the country.

Rutland may have only two towns, but in a quirk of historical fate, each happens to house a famous public school and both Oakham and Uppingham rank highly in the national lists for co-educational independent boarding schools. Their close proximity is accounted for by the fact that both were founded in 1584 by the same benefactor, but both institutions have also experienced

difficult times over the centuries and could easily have foundered but for the persistence and leadership of some inspirational headmasters.

England's smallest county does have two major highways running through it but in between the A1 Great North Road and the A47 linking Peterborough and Leicester, there lies a network of virtually traffic free minor roads and lanes. An enthusiastic tourist could cover the county in a matter of hours but to do so would entirely miss the point of Rutland. Landlocked in the very heart of England is an area of glorious countryside dotted with villages and hamlets of thatched houses of mellow golden stone just waiting to be explored at a leisurely pace rather than ticked off in a guide book, snapped on a mobile phone camera and then almost instantly forgotten. So don the walking shoes and ditch the car keys to fully savour a truly English piece of England.

ABOVE The original Belvoir Castle was built by William the Conqueror's standard-bearer, Robert de Todeni as a typical Norman motte and bailey structure, a far cry from the Gothic fantasy created in the nineteenth century that now dominates the village and surrounding countryside. Belvoir is the seat of the Dukes of Rutland, a title held by the Manners family for whom the castle has been their ancestral home for over five centuries.

The swirling mists of an autumn sunrise endow the ancient village of Empingham with a timeless quality, and apart from the few brightly tiled roofs of newly built houses, this view has probably changed very little in centuries. However, if the photograph had been taken from a reverse angle, the panorama would be very different because having once looked out over the sweeping valley of the River Gwash, Empingham now stands adjacent to the mighty dam at the eastern end of Rutland Water. Archaeological excavations carried out prior to the dam's construction revealed evidence of an Iron Age settlement, Romano-British farmsteads and Anglo-Saxon cemeteries. A site near Empingham alongside the Great North Road (now the A1) was the scene in 1470 of yet another engagement in the long running Wars of the Roses (1455-85). The Battle of Losecoat Field resulted in the Yorkist army of Edward IV defeating a rebel Lancastrian force under Sir Robert Welles.

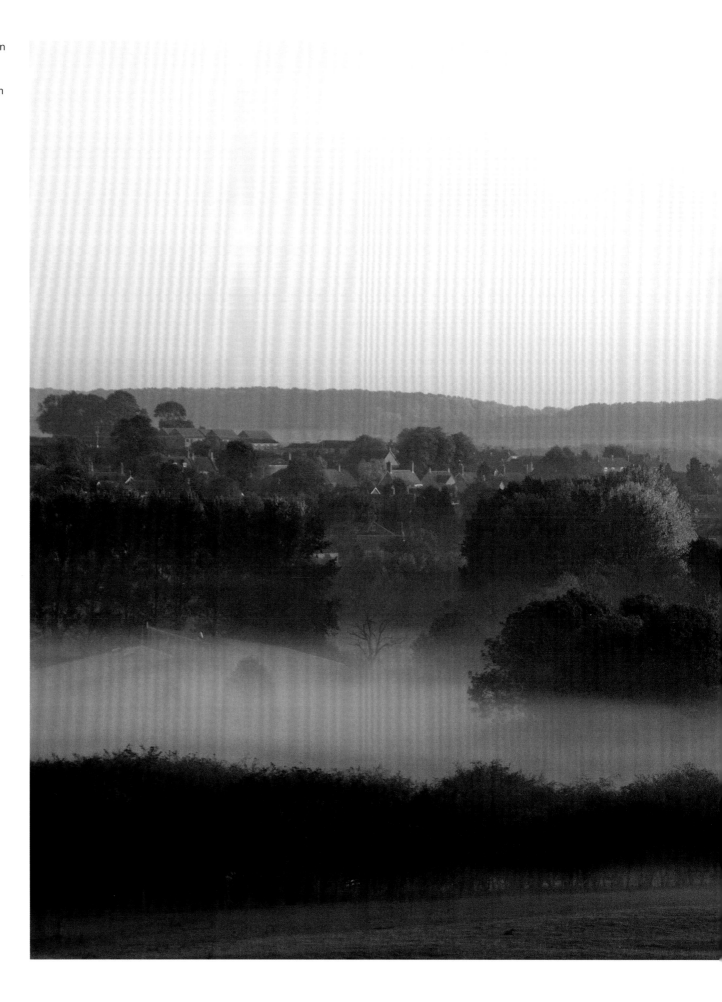

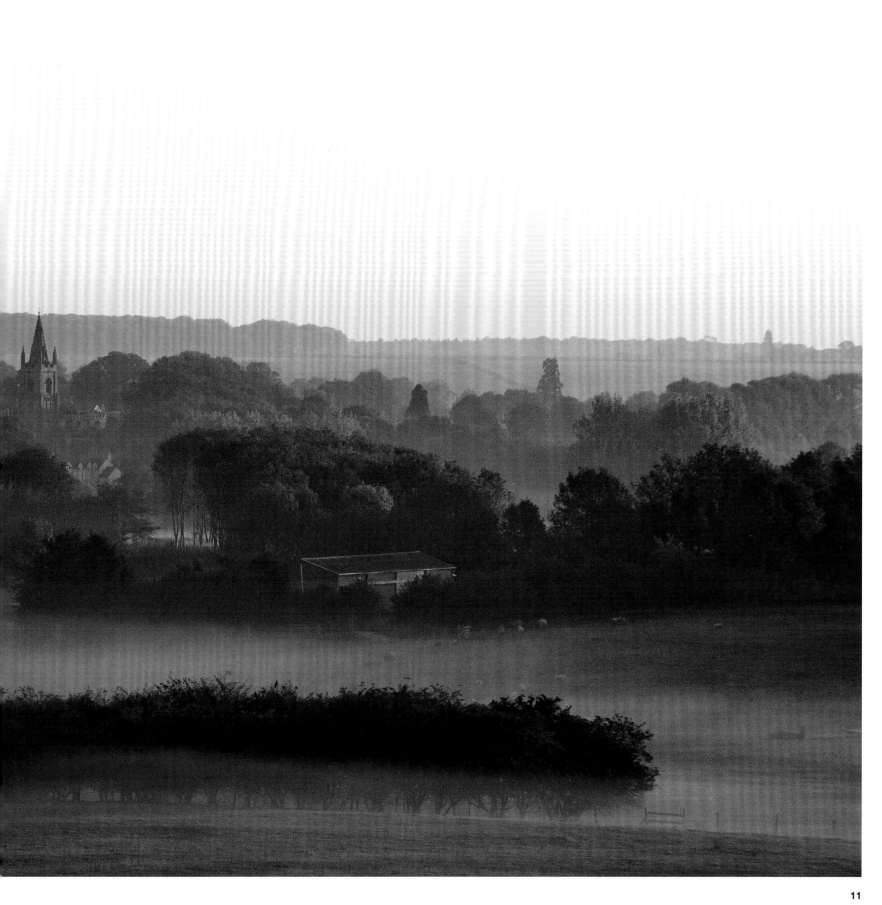

rutland water

It seems somewhat ironic that when the twin valleys of the River Gwash were flooded in the 1970s to create Rutland Water, England's smallest county at once became the site of Europe's largest manmade area lake. It was not a decision taken lightly and only went ahead after some sixty other sites had been investigated, and once the Gwash Valleys had been selected, a lengthy consultation process then ensued. The deliberate flooding and destruction of houses and the rich arable land farmed for generations by the same families is a hugely emotive issue but the demands for water from both industry and an ever-growing population within the East Midlands region had to be met and a new reservoir was the only solution. The Rivers Nene and Welland were well placed to supply the reservoir, clay was readily available within the site for dam building and the natural shallow amphitheatre created by Rutland's gently undulating landscape reduced the need for vast banks and walls of stone and concrete. The mighty dam constructed to contain the reservoir at its eastern end near the village of Empingham is 35 metres high, over 800 metres wide at its base and over a kilometre in length.

Although originally designated the Empingham Reservoir, the authority responsible for the project, Anglian Water, succumbed to local opinion by subsequently renaming it Rutland Water. Construction started in 1971, filling began four years later and by 1979 the reservoir was full. It must have been traumatic for the people of Rutland to witness the desecration of their treasured environment but during the three decades since its completion, Rutland Water has evolved into a priceless wildlife sanctuary, an important leisure and sporting facility and a significant source of revenue to the county as a whole through additional tourism.

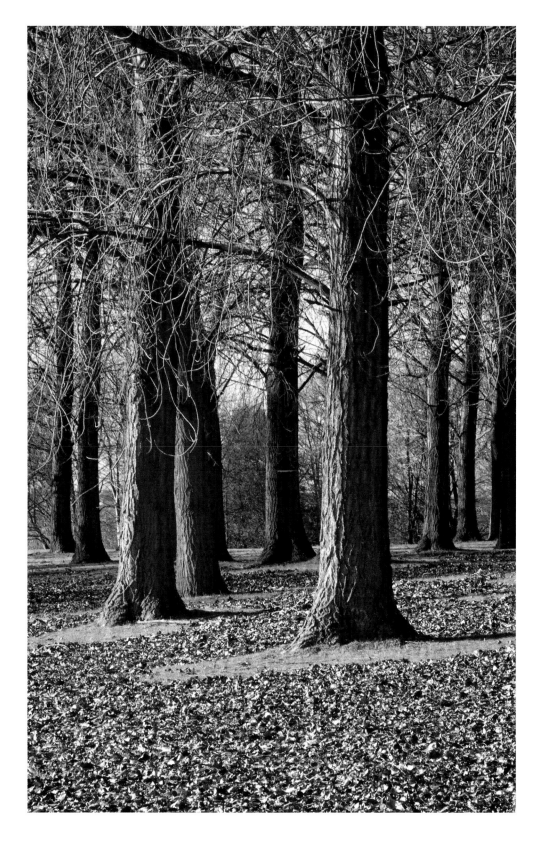

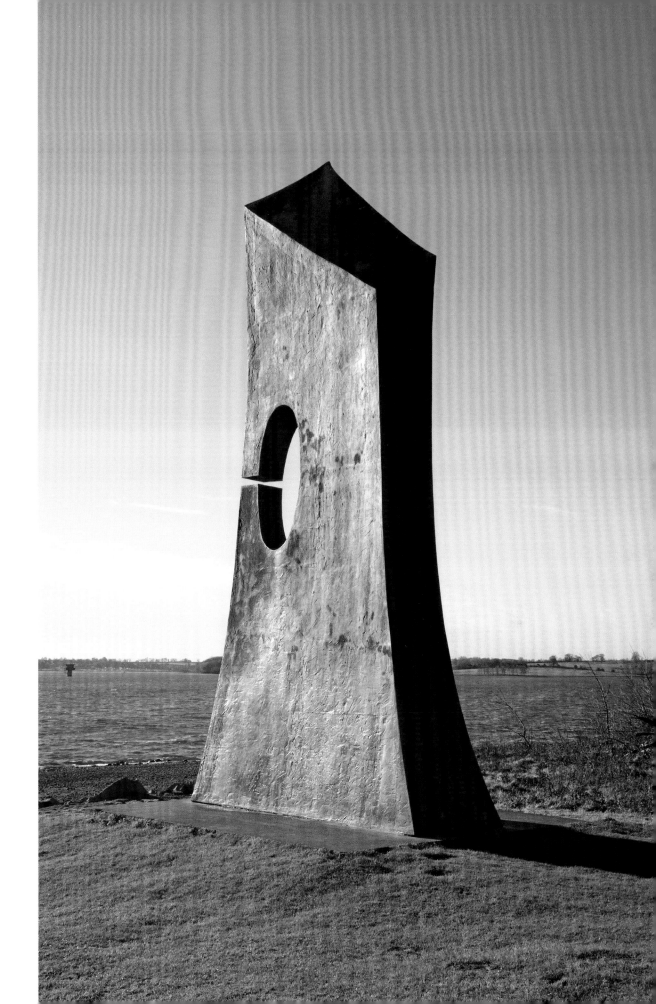

LEFT When the construction of Rutland Water was completed, landscaping of the reservoir's immediate environs began. Initially, some of the areas now designated as car parks and visitor centres were bleak and desolate places but an intensive planting regime of new trees designed to merge and blend in with existing copses has now come to fruition. The trees at Sykes Lane are set back from the water's edge on raised ground, with the shoreline now fringed by reeds and other grasses creating additional protection and habitats for wildlife.

RIGHT The 30 foot-high bronze sculpture by Alexander was unveiled in 1980 and stands on the north shore of Rutland Water adjacent to the Sykes Lane Visitor Centre. It was commissioned on behalf of Anglian Water by the International Arts Foundation, a charity funded by private donations and bequests established to promote the work of up and coming artists. The overall cost of the project was £50,000 and even though little of that sum came from either public funds or the water authority's budget, there were serious rumblings of discontent from many locals about spending so much on a piece of art. Many of its detractors had not even seen the Great Tower and were simply objecting on the grounds of principle, but most had the grace to later acknowledge that they had warmed to the sculpture.

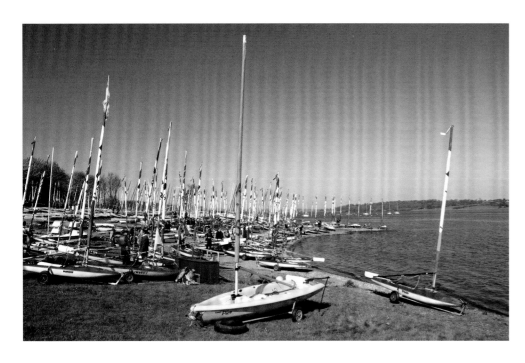

Although Rutland Water has a huge overall surface area, the long Hambleton Peninsula effectively divides the reservoir into two adjoining lakes and both northern and southern halves are surrounded by gently rolling low rise hills and punctuated by numerous bays, spits and inlets. All these natural features combine to provide a visually appealing environment in which to sail, and perfect locations at which to house water borne sports centres. The main centre for sailors is the Rutland Sailing Club at Edith Weston, located almost directly opposite the tip of the peninsula's tongue on the south shore. The 13 acre site comprises a modern clubhouse, several concrete slipways, pontoons with connecting walkways and during the height of summer on weekend race days, the foreshore is festooned with masts rising from yachts of all shapes and sizes. One of the

most impressive aspects of the Sailing Club is that it is also the base of Rutland Sailability, a registered Charity that enables people with disabilities to enjoy the physical challenges of sailing; work for which the organisation was honoured with the Queens's Award for Voluntary Service in 2010.

Sailing is a great leveller as the elements take no heed of age or social standing and although physical strength is a factor, having an intuitive feel for the boat and the wind counts for an awful lot. A sailing venue such as Rutland Water that offers tuition to RYA standard is an invaluable resource, especially as it has a catchment area spread over a wide area of central England. The topography of the surrounding landscape can help generate challenging conditions and anyone who has experienced the thrill of hurtling over white horses in a 'seat of the pants' craft such as a Laser dinghy will be forever hooked. Races may look confusing to the onlooker and although it may appear that no quarter is being asked or given, there are strict rules and each heat is monitored by officials in motorboats in the midst of the action. Water in reservoirs may ultimately be destined for drinking and turning the wheels of industry but it is also a great medium for fitness and recreation.

OVERLEAF When the level of Rutland Water is well down, the exposed areas of foreshore often reveal curiosities dating from when the outer perimeters of the reservoir were being landscaped in preparation for flooding. These exposed stumps and roots of felled trees sitting on the mud and shingle exposed at low water exuded a surreal quality in the reddening light of sunset.

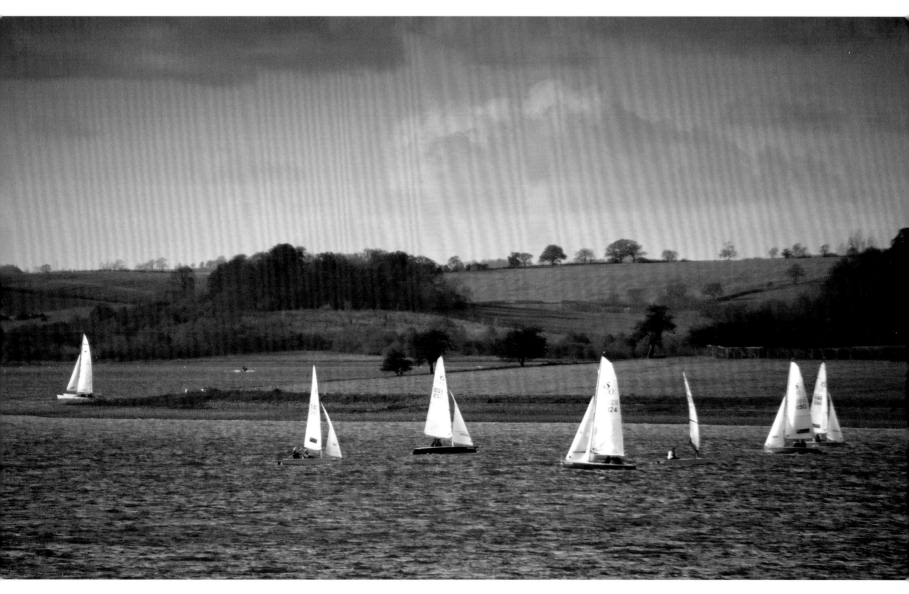

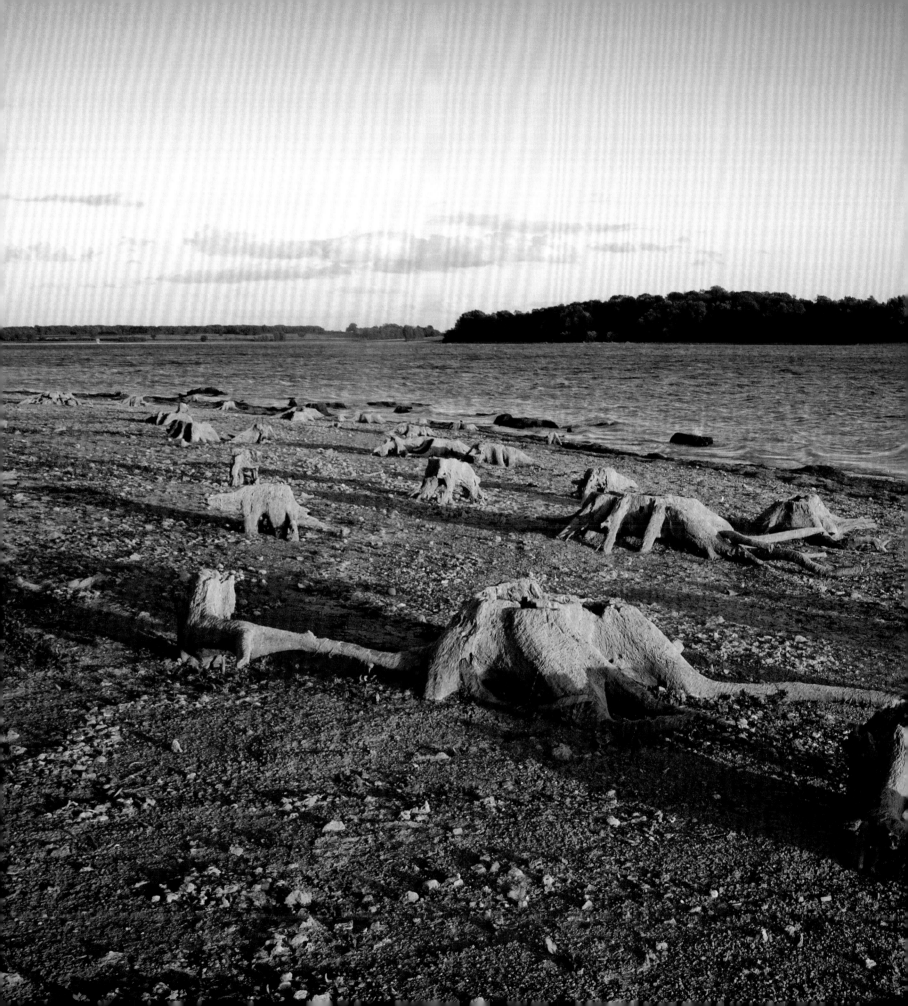

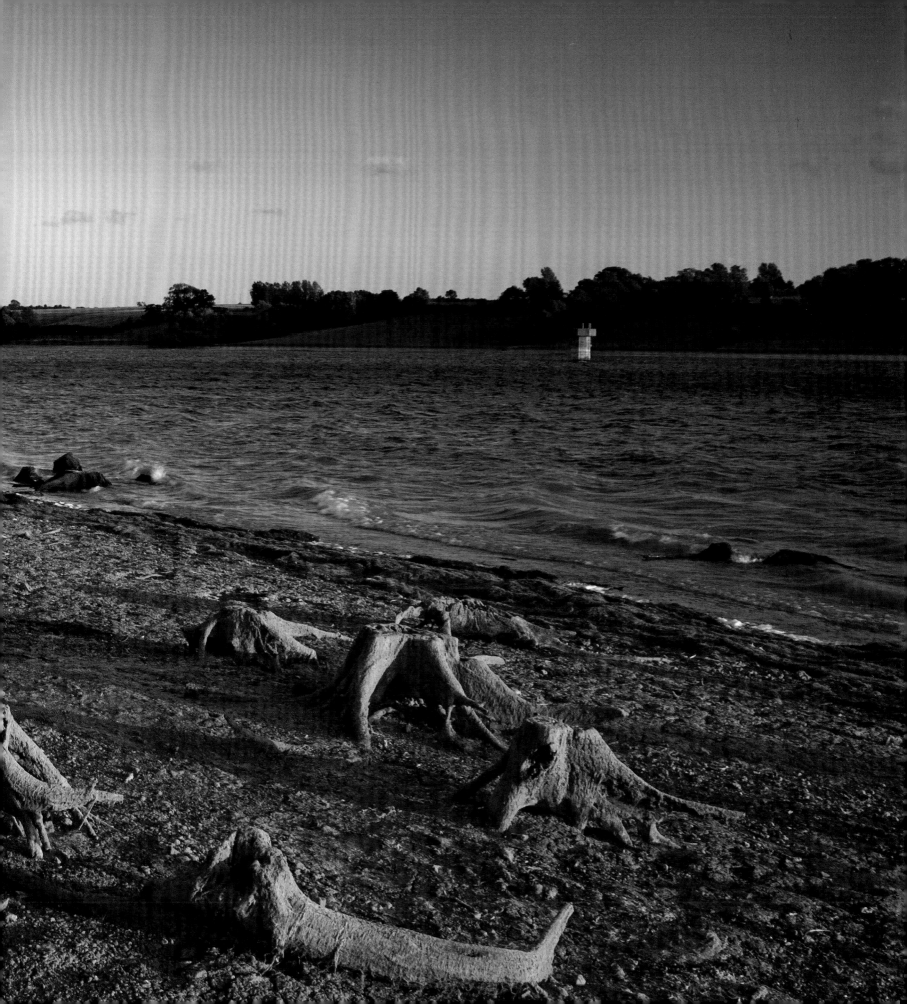

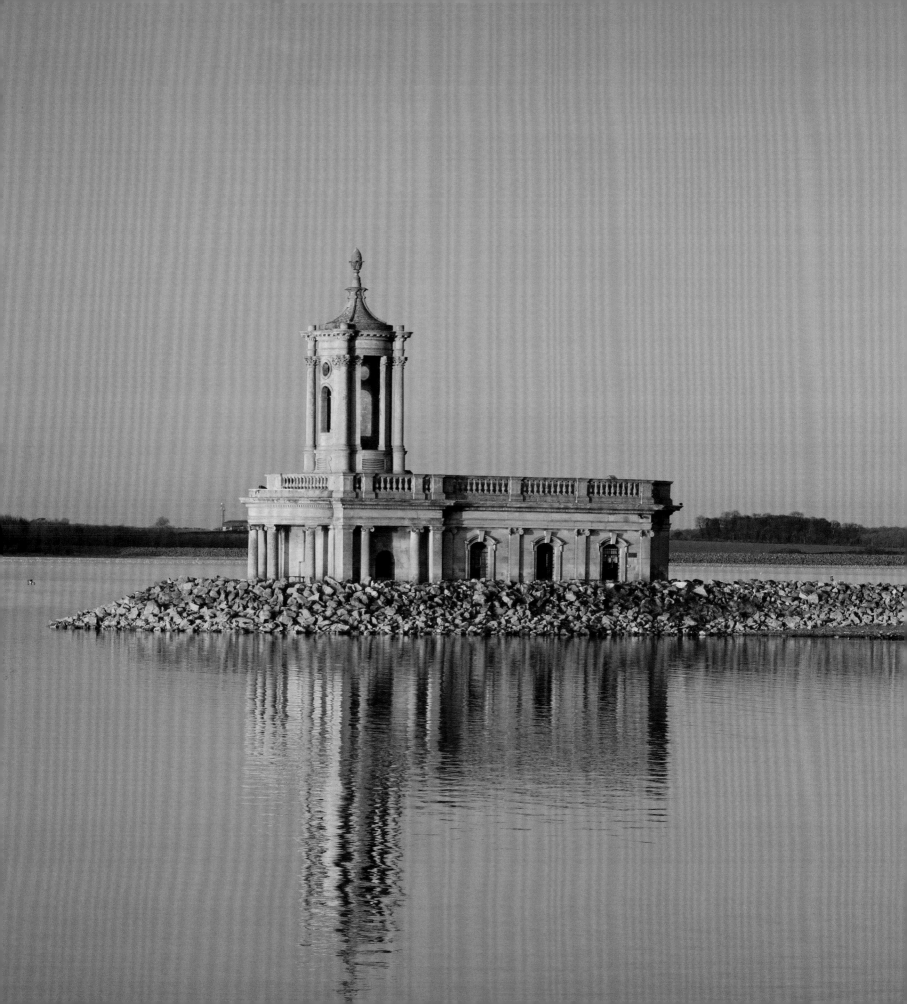

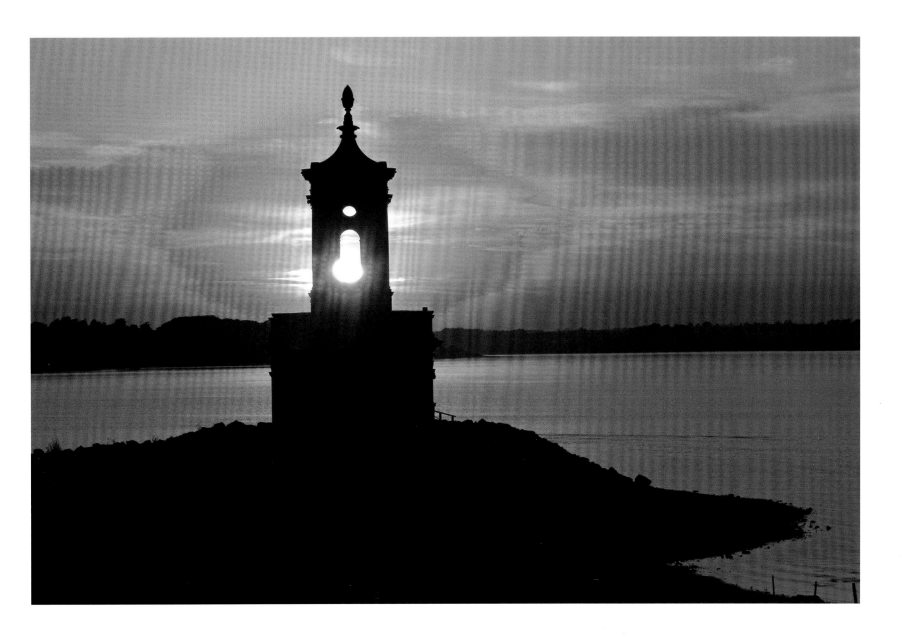

The 'floating' church at Normanton on the south shore of Rutland Water is almost certainly the county's most iconic image and a triumph of conservation. St Matthew's was the private estate church of the Heathcote family (later Earls of Ancaster) who owned the great mansion of Normanton Park and who, in common with many other eighteenth century landowners, had demolished much of the existing village to make way for their country seat. The original church was built in 1764, with the west portico and distinctive tower being added in 1826, the latter being the work of Thomas Cundy (1790–1867), surveyor of the Grosvenor Estate in London who used St John's, Smith Square as his inspiration for the remodelled tower.

In the *Collins Guide to the Parish Churches of England and Wales* edited by Sir John Betjeman first published in 1958, the entry for St Matthew's was hauntingly prophetic when suggesting that the church 'stands entirely alone, sailing like a white ship across the wide green seas of the park'. How utterly appropriate to make that analogy, but the author of those words would have had no idea that the green expanses of Normanton Park would become an inland sea and that the good ship Matthew might well have been holed below the waterline and sunk without trace. This beautiful and elegant estate church that was deconsecrated in 1970 would have been lost were it not for the concerted campaign by a Trust formed specifically to raise funds to secure the building's future.

Numerous options were considered and the solution finally decided upon seems to have successfully resisted three decades of winter storms. The interior of the church was filled with rubble up to window height and then capped with concrete to create a new floor level. The exterior walls were treated with waterproofing material, protected by clay banks which were themselves encased by great stone blocks to create a massive breakwater around most of the church's perimeter. The same principle was used to construct a causeway linking the church with dry land and it now serves as a museum containing a history of Rutland Water and archaeological finds made during the excavations. When reservoir levels are low, the immediate environs of the church resemble a giant rockery without the softening effect and added colour of Alpine plants but when Rutland Water is full and the top layer of stones barely protrude above the surface, that quite extraordinary illusion of a floating church returns.

spring

Spring is by far the most visually appealing of the four seasons and to witness nature's annual process of renewal is a privilege that cannot be understated. We live in an automated, increasingly technological age where shortcuts are the expected norm and time always seems to be in short supply. Farmers are even more hard pressed by those shortages of precious time, money and labour, but for them the cycle of birth, growth and harvesting of both crops and livestock has an unwritten timetable seldom capable of being artificially manipulated.

Predicting when everything is likely to happen is not an exact science that can be precisely determined by the computers relied upon by twenty-first century industry and commerce but largely on how cold or wet the preceding months have been. Even within a geographic area as small as Rutland, distinctly varied micro-climates prevail in the different sectors and conditions on the limestone escarpments of the Cottesmore Plateau will vary considerably from those amidst the low-lying open pastures and large arable fields of the Welland Valley.

However, regardless of how harsh the winter has been, the hedgerow and woodland flowers will unfailingly appear, lambs will joyously discover their capability for vertical take-off from spring loaded legs, and the dark, drab days of winter will soon be a passing memory. As the days gradually being to lengthen, the countryside sloughs off the drab skin of winter and replaces it with fresh, shiny green.

A misty, dew laden sunrise heralds the start of another spring morning for sheep and lambs grazing near the Eyebrook Reservoir. Although the profound agricultural changes of the mid-eighteenth century resulted in the enclosure and ploughing of large areas of eastern Rutland's traditional grasslands, the ridges and valleys to the west of the county have retained a more rural feel and it is here that traditional mixed farming predominates.

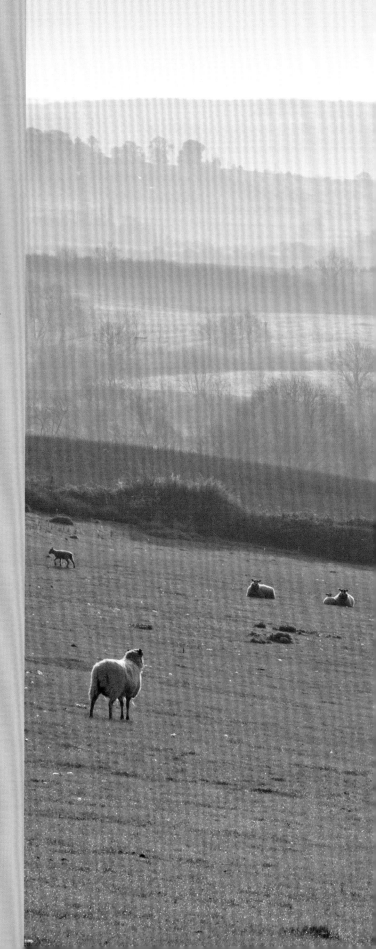

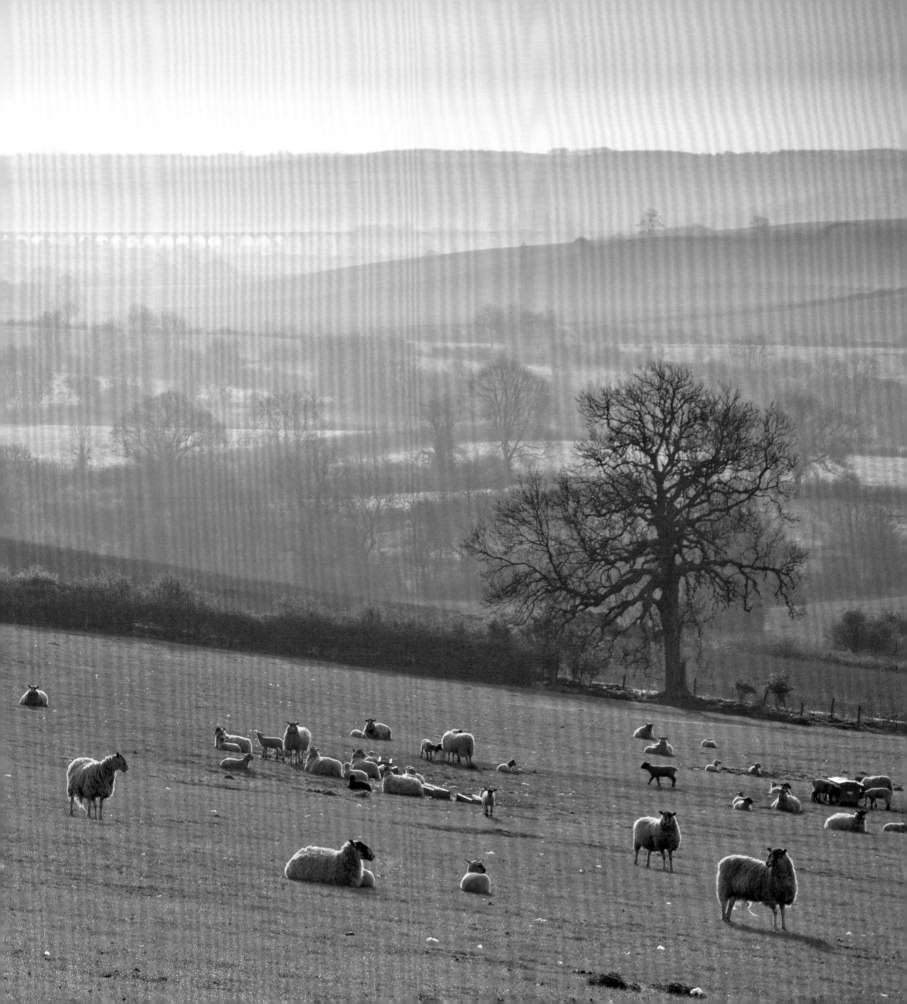

When the Blackthorn hedges and bushes are in full bloom during the early days of spring, the densely packed white blossom appears as a joyously mocking parody of the past winter's heaviest hoar frosts. I was particularly drawn to this location because I was able to find an elevated shooting position that enabled me to look down on the geometric parallel lines of tractor tyre tracks etched into the light sandy soil. I always relish the challenge of trying to aesthetically unite the randomness of nature with the more regulated human imprint upon the countryside. It doesn't always work but I am pleased with this effort!

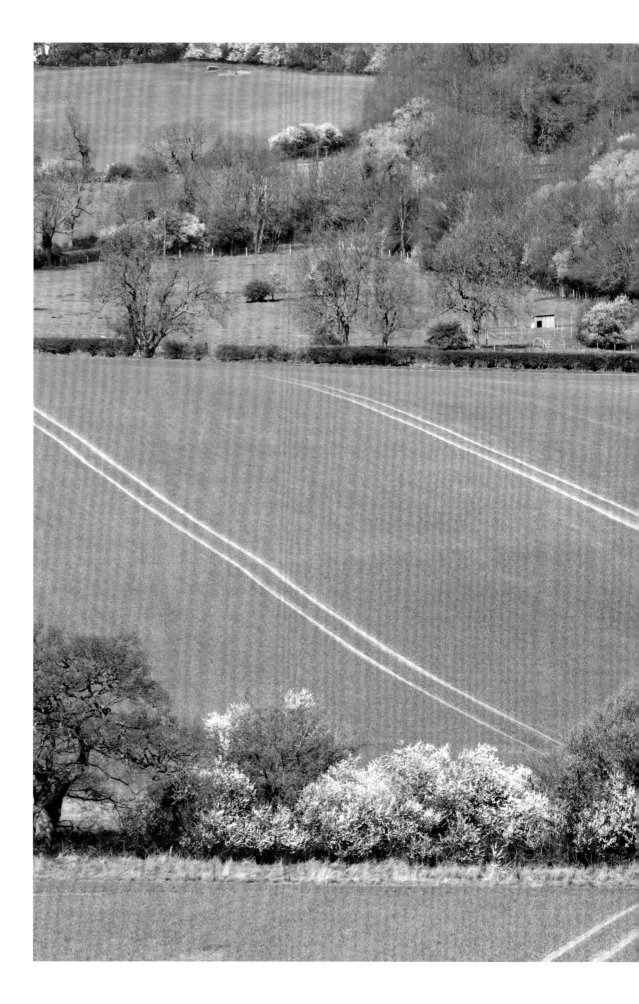

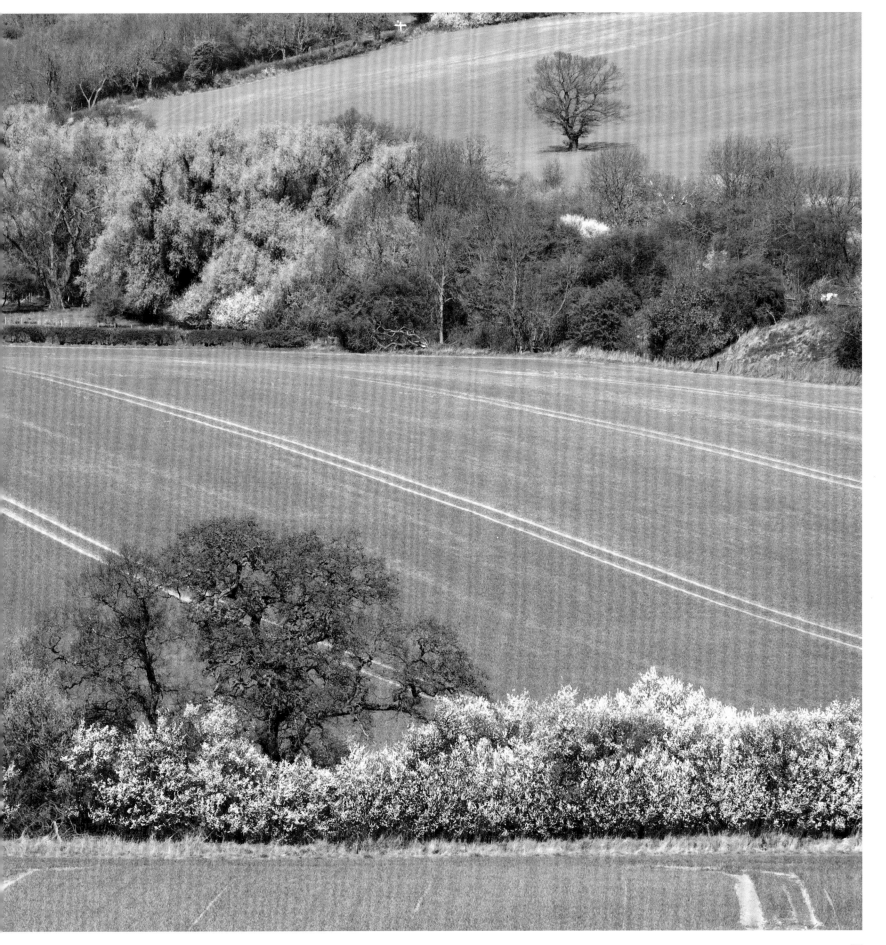

BELOW The ha-ha is all that remains of the original seventeenth century Luffenham Hall and it now forms the southern boundary of the local primary school's playground. The hall was acquired by Edward Noel, Viscount Campden in 1635 as a permanent residence for his son, Henry Noel. During the Civil War it was besieged by a Parliamentary force numbering some 1,300 men under the leadership of Thomas, Lord Grey and although hopelessly outnumbered, Noel held out for 24 hours before accepting terms for surrender. Unfortunately for him, the deal was reneged upon and he was sent to the Tower, the house and village pillaged and monuments in the church defaced. Despite having supported the 'wrong' side in the Civil War, the Noels were allowed to keep the manor until it was sold during the early eighteenth century but the hall gradually fell into an extreme state of disrepair and was demolished in 1806.

RIGHT The turf cut maze located on the outskirts of Wing is thought to be one of just eight surviving examples in England. Its precise age is not known but could well date back to the late medieval period and this particular configuration is almost identical to the one set into the nave of Chartres Cathedral in France. Mazes were adopted by some quarters of the Christian Church as a form of penance and also featured in the post Crusade era of the thirteenth century as a means of enabling would be pilgrims to make an intense spiritual journey without travelling to Jerusalem. I have witnessed people using the maze in Chartres, crawling round and round the intricate labyrinth on their hands and knees, totally oblivious of the constant bustle and chatter of passing tourists. In the gazetteer entry for Wing in the Leicester and Rutland Directory of 1846, it was described as 'an ancient maze, in which the rustics run at the parish feast'.

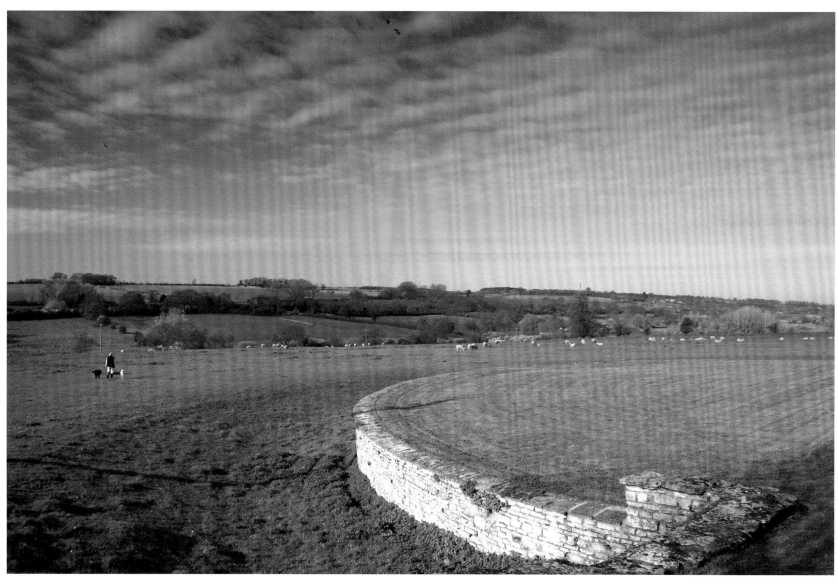

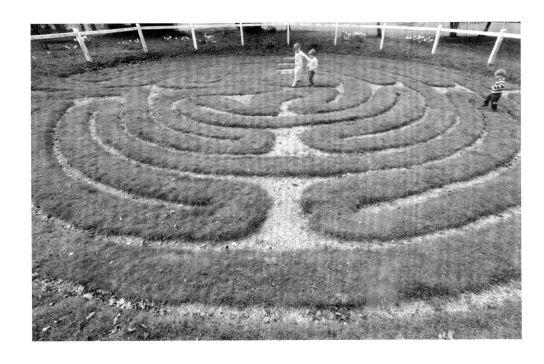

BELOW These neatly clipped hedgerows near Wing are just beginning their transition from winter to spring as the first tentative hawthorn leaves start to appear. Wide, species rich grass verges are a typical feature of Rutland's rural lanes and provide an invaluable wildlife habitat. The wild flowers and grasses encourage insects and butterflies, dense hedge growth and mature hedgerow trees provide nesting, burrowing and breeding sites for birds and small mammals.

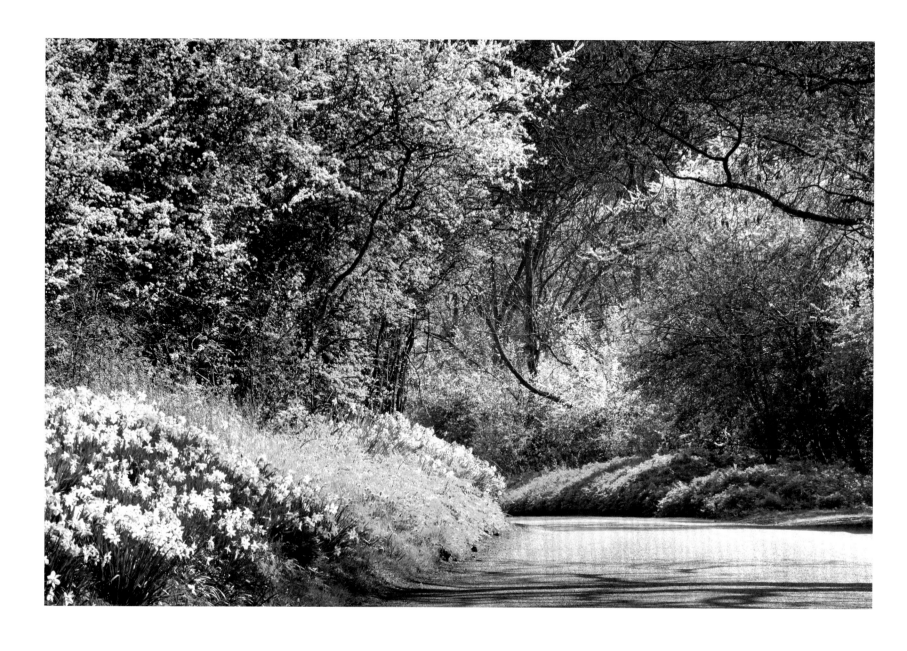

ABOVE Several of the narrow country lanes linking the cluster of villages lying to the south of Rutland Water are emblazoned in spring with huge blackthorn bushes encased in snowdrifts of white blossom, augmented in places by banks of complementary coloured daffodils.

OPPOSITE, CLOCKWISE FROM TOP LEFT Daffodils, beech leaves, wild primroses, cowslips

OVERLEAF Barrowden is the epitome of many people's idea of a traditional English village; spacious greens linked by narrow lanes of stone houses and cottages, a close grouping of village pub, duck pond and a parish church adorned by a tall, elegant spire. Barrowden's location close by the River Welland ensured that water played a part in the village's economy and a mill was listed as early as 1257. A replacement mill occupied the same site when erected some four centuries later in 1637 to generate power for a tannery that remained in business until 1885. The seventeenth century mill was in the ownership of John, Earl of Exeter whose links with Barrowden are maintained via the village pub, the Exeter Arms.

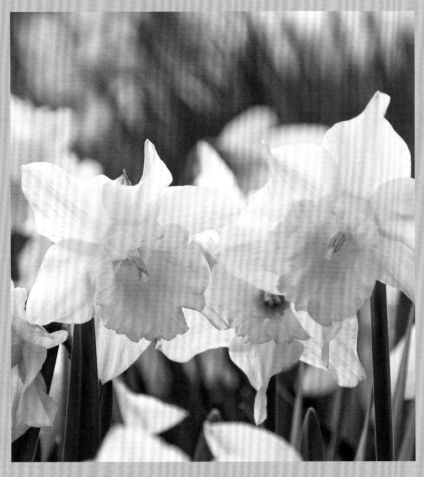

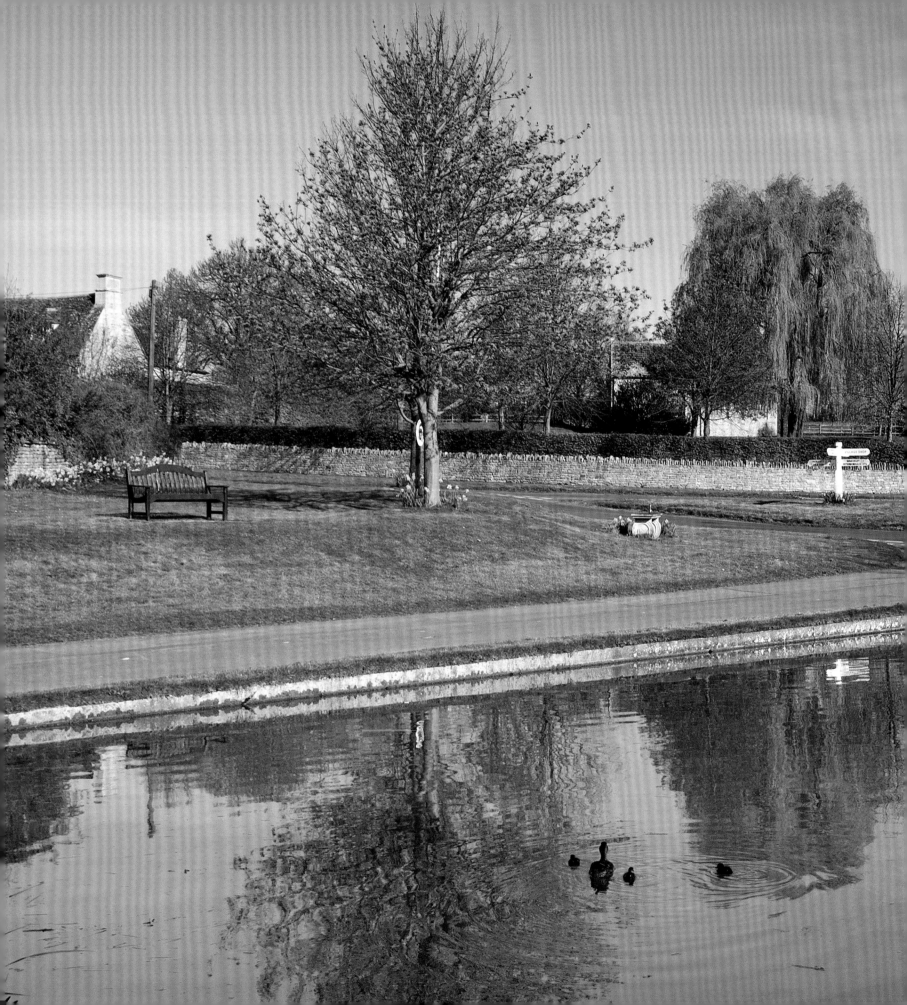

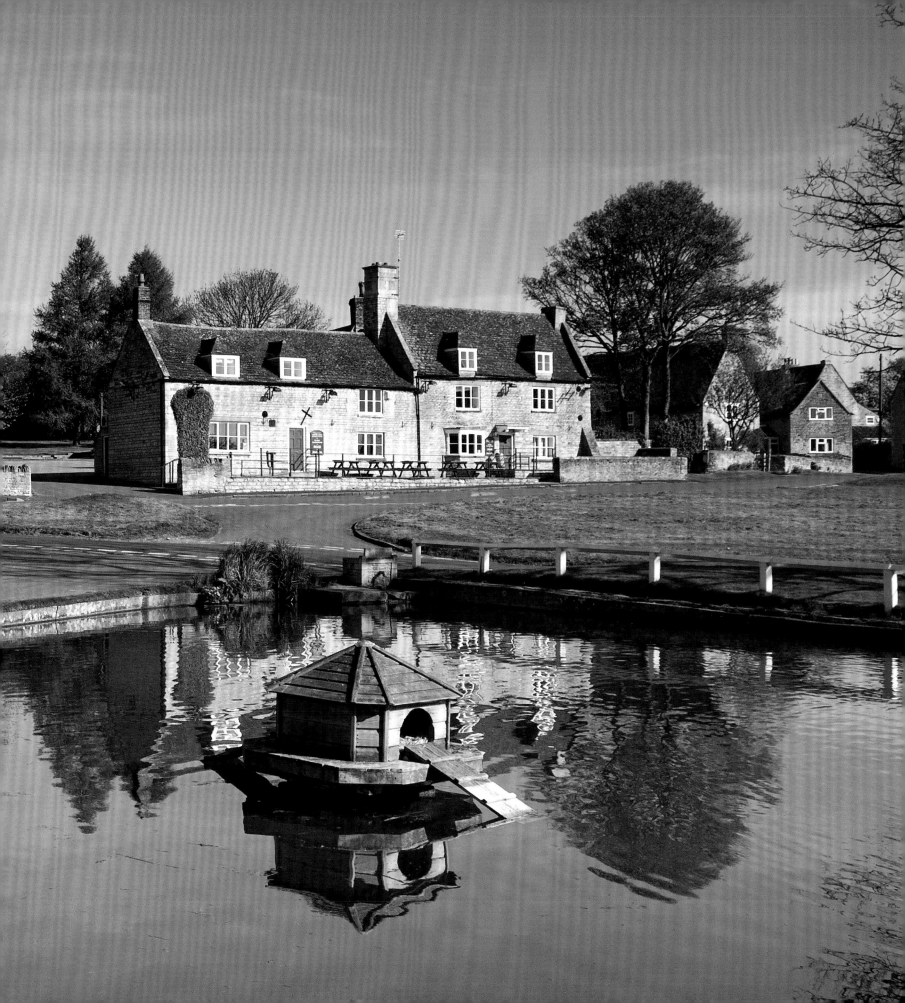

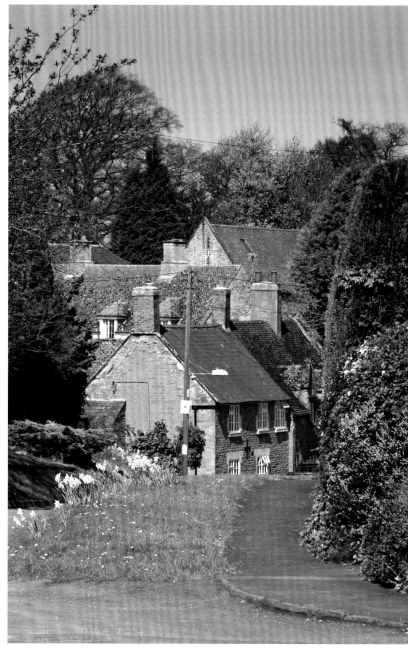

ABOVE Ashwell is a small village set amidst vast tracts of gently undulating farmland to the north of Oakham. The early seventeenth century Home Farm is Ashwell's oldest dwelling and was built on the site of an earlier ninth century Saxon settlement that has yielded archaeological finds of pottery and other artefacts. The Rutland Railway Museum is located nearby and is largely dedicated to recounting the history of railways within the context of the region's ironstone quarrying industry.

ABOVE Despite its close proximity to the main road linking Oakham and Uppingham, Preston nevertheless retains an air of seclusion. The majority of its houses and cottages are built from locally quarried ironstone with either Collyweston slate or thatched roofs. Although the village itself was not mentioned by name in the Domesday Book, the church of St Peter and St Paul does have several distinctive Norman features and various members of the famous De Montfort family (Earls of Leicester) held the manor of Preston during the early medieval period.

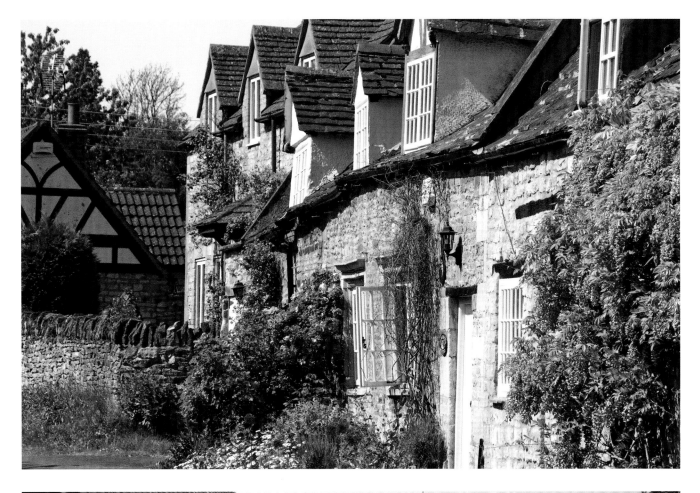

LEFT ABOVE There are several groups of almost identical cottages in Exton, built by the lord of the manor to house estate workers, their families and local tradesmen. Although the term 'model village' is more often associated with industry related communities such as Port Sunlight or Bourneville, many English country landowners also managed their workforce in the same way. Model was used in the context of being something to aspire to rather than a tourist attraction of miniature houses and shops! Much of Exton's current layout can be attributed to Charles Noel, 2nd Earl of Gainsborough (1818–81) due to his decision to clear most of the workers' cottages from the lane leading up to the church and also from another road leading through the Park, the delightfully named Pudding Bag Lane. All those families were relocated into the purpose built houses down in the main village. One of the key elements of such model villages was their self-sufficiency, an attribute reflected in the surviving street names and small yards dotted around the village, although the last blacksmith to actually work in Blacksmith's Lane perished in the Great War.

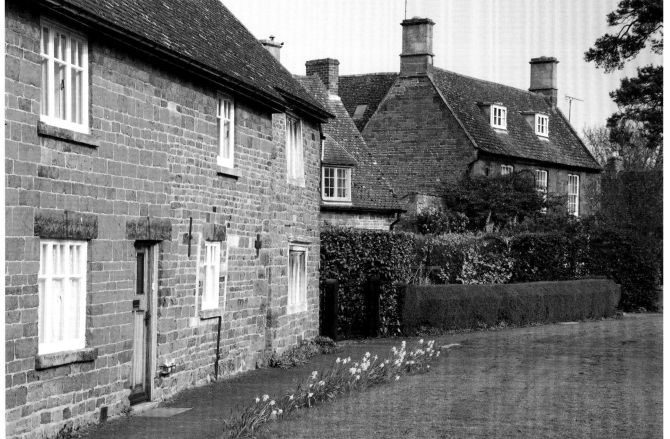

LEFT BELOW Despite housing the base and shaft of a fifteenth century cross and being flanked by richly coloured stone cottages, Lyddington's green is not the focal point around which the village was built but merely one portion of the mile long Main Street. Lyddington is an architectural treasure trove and more than justifies its status as the county's showpiece village.

LEFT In the medieval era of the thirteenth and fourteenth centuries, Market Overton was firmly established as a market town serving the rich agricultural area in the north of Rutland. The surprisingly well-preserved stocks and whipping post on the village green serve as a reminder of the times when flogging, or a period locked in the stocks was the summary justice meted out for petty offences. The stocks were an ideal solution for dealing instantly with itinerant travellers and traders who had broken the law and although offenders faced the pain of corporal punishment for more serious crimes, the public humiliation associated with being put in the stocks often served as an equally effective deterrent.

RIGHT Village greens come in all shapes and sizes and the small triangle in South Luffenham is now almost completely taken over by a huge red chestnut tree, a vibrant red K6 telephone kiosk and a telegraph pole. The village green was once a place of traditional communal celebration, not least on May Day, when children would dance around the maypole and the May Queen and her entourage would parade grandly round the village on farm wagons bedecked with garlands and horse brasses. That event and others such as Wassailing and Ploughboy Monday that once were such integral parts of rural communities disappeared from the parish calendar many decades ago.

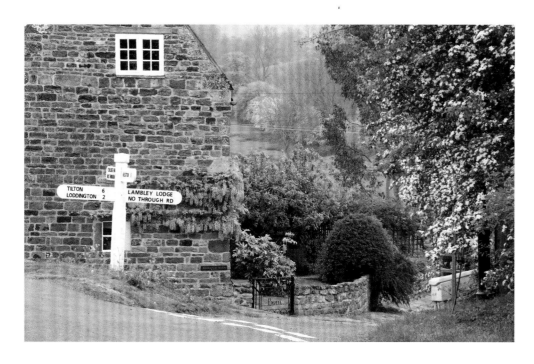

LEFT The undulating land surrounding Belton-in-Rutland once formed part of the ancient Leighfield Forest, created by Henry I in the early twelfth century as just one of the many tightly regulated Norman hunting forests established around England. A narrow lane leads enticingly down from the village towards the seventeenth century farmstead of Ambley Lodge before petering out into a bridle track and footpath leading onwards amidst glorious countryside to Leigh Lodge, a sixteenth century Grade II Listed house that still retains its original fish ponds. This walk is just one of countless options available via the extensive network of well signposted public rights of way and bridleways across Rutland that enable the creation of circular expeditions to suit ramblers of all fitness and stamina levels.

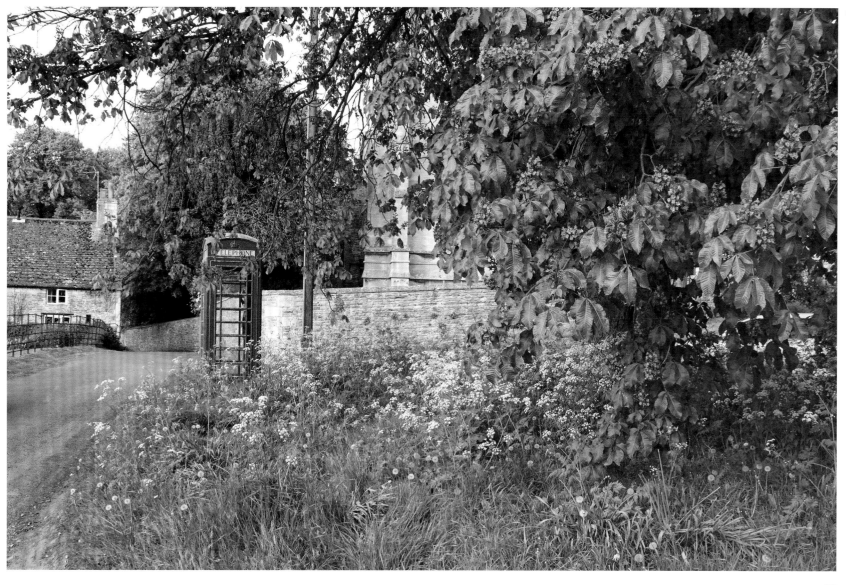

LEFT Bluebells are unquestionably beautiful flowers in their own right, but when massed together and set amidst the fresh green of beech trees in spring, they create a glorious two tone collaboration that serves as a harbinger for the imminent broader colour palette of summer foliage and wild flowers.

RIGHT ABOVE Barnsdale Gardens were created by the late Geoff Hamilton (1936–96), the iconic and much loved presenter of BBC Television's Gardener's World from 1979 up until the time of his death. Barnsdale comprises thirty eight different gardens, many of which were created in front of the TV cameras to demonstrate various gardening techniques. One of the most visually arresting features is the apple arch, a metal pergola adorned with around thirty different species of fruit trees planted as year-old whips and subsequently pruned and trained over time into perfect symmetry.

RIGHT BELOW Hedge laying is a vital rural industry and one thankfully undergoing a resurgence in many parts of England. If left to their own devices, hedges will just keep on growing upwards into tall, straggly trees with no substance or covering around ground level and although post and barbed wire fencing does the basic job of containment, laying a hedge not only produces an effective livestock barrier and place of shelter in adverse weather but also becomes a haven for wildlife. The stems are cut with a razor sharp billhook, bent over at an angle to create an impenetrable barrier against sheep, stakes are then driven through the centre of the hedge and their tops tightly bound with long, twisted lengths of hazel or similarly pliable wood.

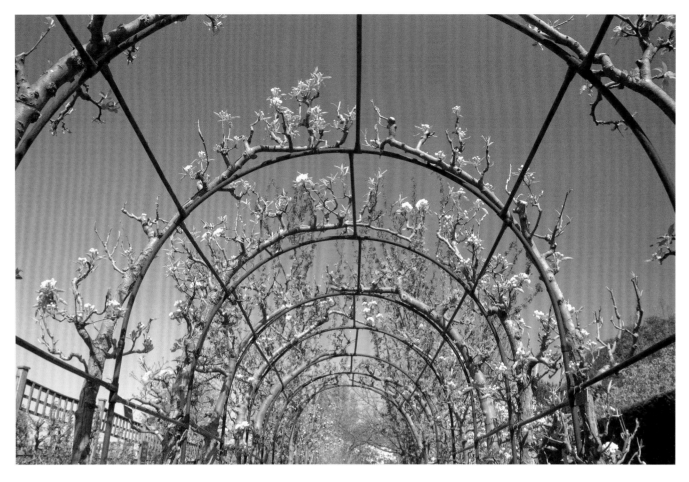

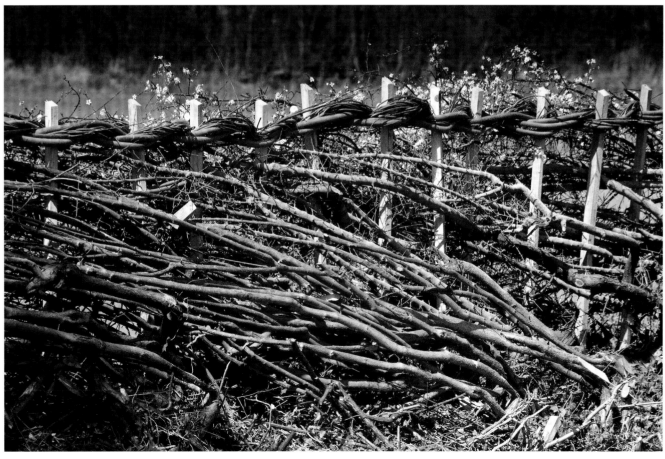

BELOW Cow parsley is a common hedgerow weed and therefore by dictionary definition 'a plant growing where it is not wanted'. However, regardless of its classification, the plant's frothy white flowers significantly enhance the aesthetic beauty of the tree-lined avenues radiating from the diminutive estate village of Lyndon. Cow parsley grows rapidly as spring progresses, with its umbrella-like clusters blossoming between May and June and is just one of many native species forming an important link in the wildlife food chain.

OPPOSITE These fields and hedges on the outskirts of Exton clearly illustrate how nature and agriculture have combined in recent decades to transform the customary colours of springtime into a searing blend of white and yellow. The heady scent of a rapeseed field may not be to everybody's liking but the crop is here to stay and production is rising year on year. Bees make superb honey from it and cold-pressed extra virgin rapeseed oil is rapidly becoming the 'must have' ingredient in many domestic and restaurant kitchens.

OVERLEAF Rutland's gloriously diverse landscape character is perfectly exemplified in this photograph of the countryside near Wing. Mixed arable farmland is liberally interspersed with ancient broadleaf woods and although the bright yellow rapeseed field appears somewhat garish, any visual discord is more than offset by the field's pear-shaped elegance and the presence of exposed areas of rich ochre coloured soil.

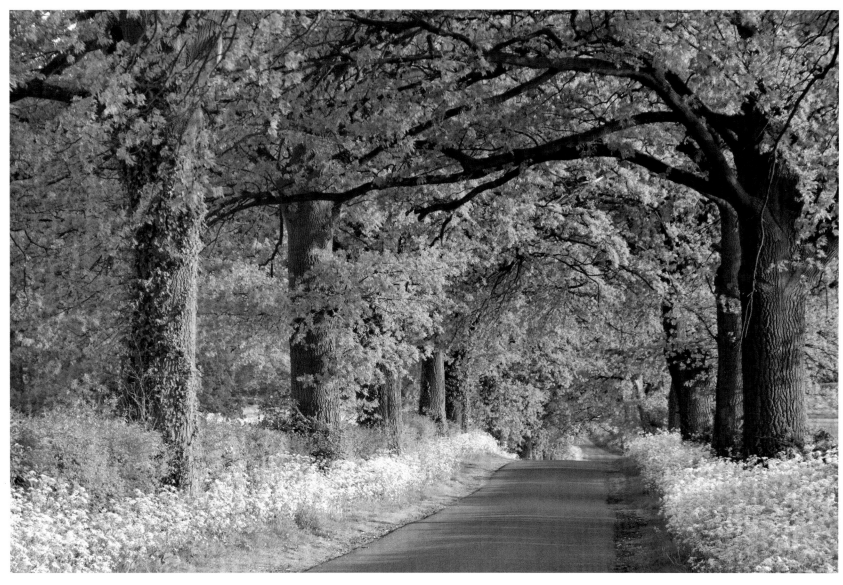

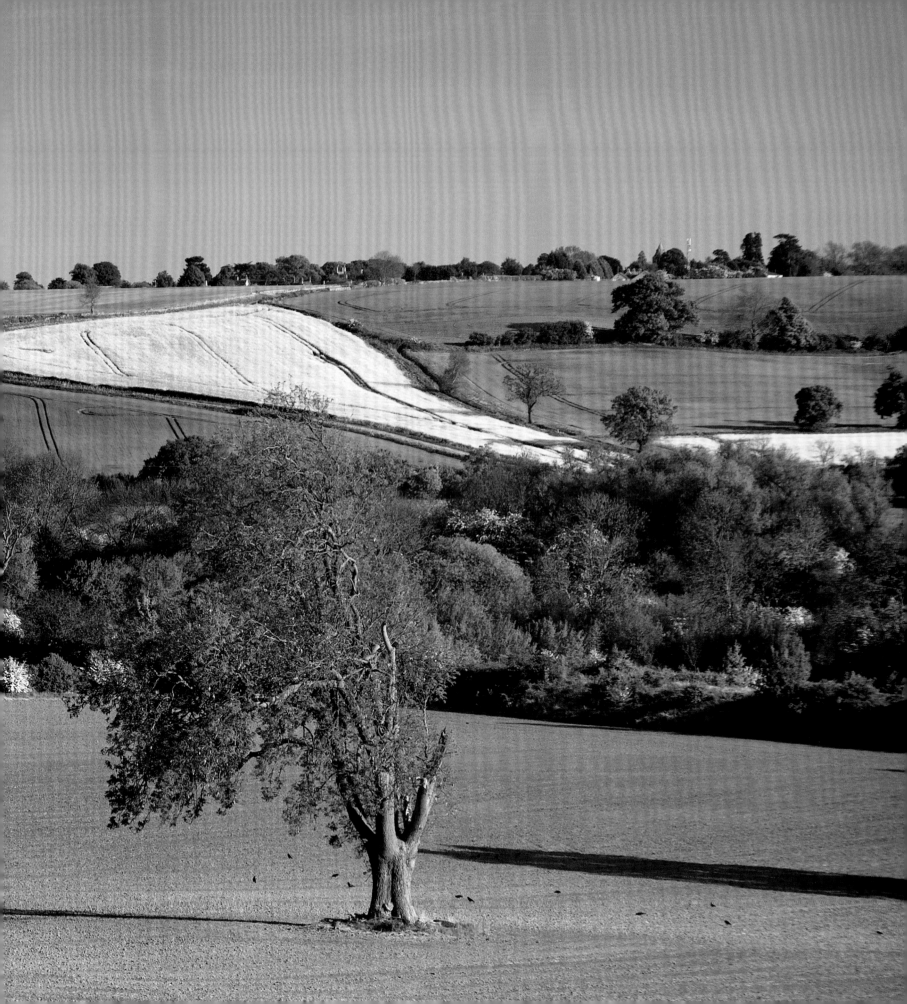

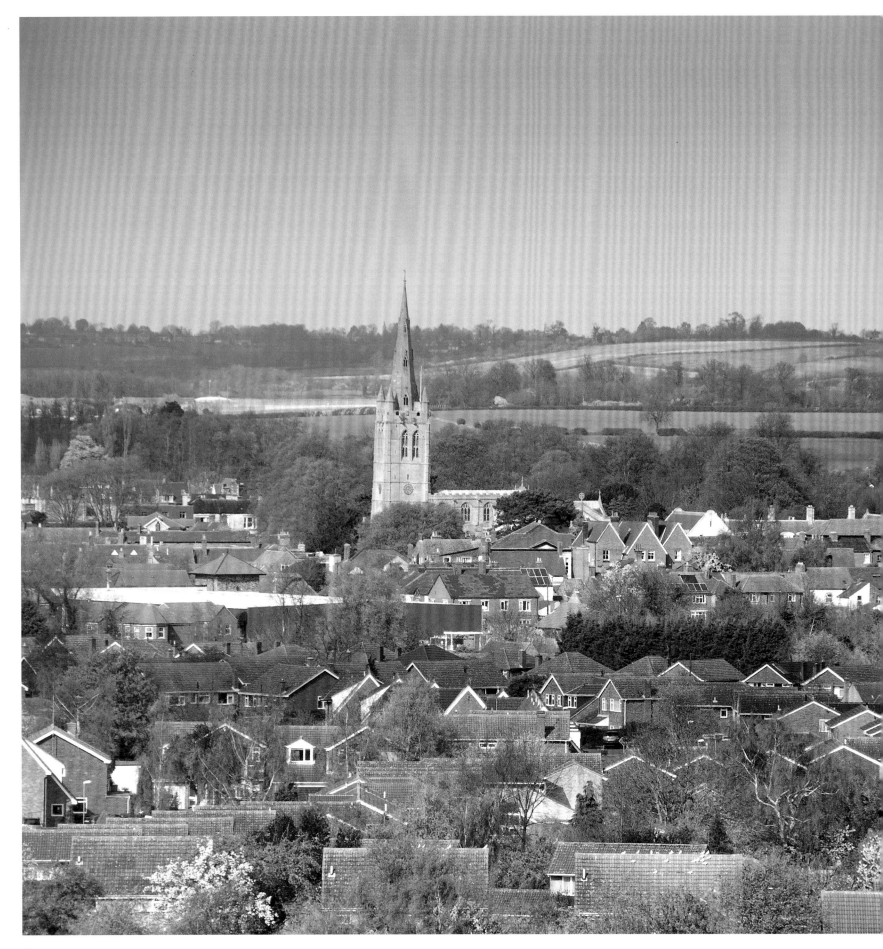

rutland towns

Oakham is the county town of Rutland and lies at the head of the Vale of Catmose, just a short distance from the western tip of Rutland Water. One of the county's most recognisable landmarks, the impressive fourteenth century spire of All Saints' Church, dominates the skyline from all directions. In common with other towns of Norman or medieval origin, Oakham initially grew up around the castle and gradually expanded outwards as trade, and therefore prosperity, increased. The market place and High Street seem to mark the limits of the original settlement and it is within that comparatively small area that some of the best surviving examples of domestic architecture are located, the oldest of which is Flore's House. Standing close by Bargate, one of the town's medieval entrances, the house dates back to the fourteenth century and was owned by William Flore who was Controller of Works at the castle from 1373–80 and whose son, Roger Flore, was elected Speaker of the House of Commons four times between 1416–22.

Most of Oakham's older houses were built from locally quarried marlstone with Collyweston slate roofs but a surprising number of brick buildings were erected during the late eighteenth and early nineteenth centuries. By that period, justice had also progressed onwards from the stocks and whipping post and in 1811, the New County Gaol was proudly opened but then quietly closed some six decades later with rather less ceremony due to a dearth of inmates!

Oakham may have expanded rapidly in recent years but the town's historic core centred around the castle, church, market square and famous public school has lost none of its original atmosphere.

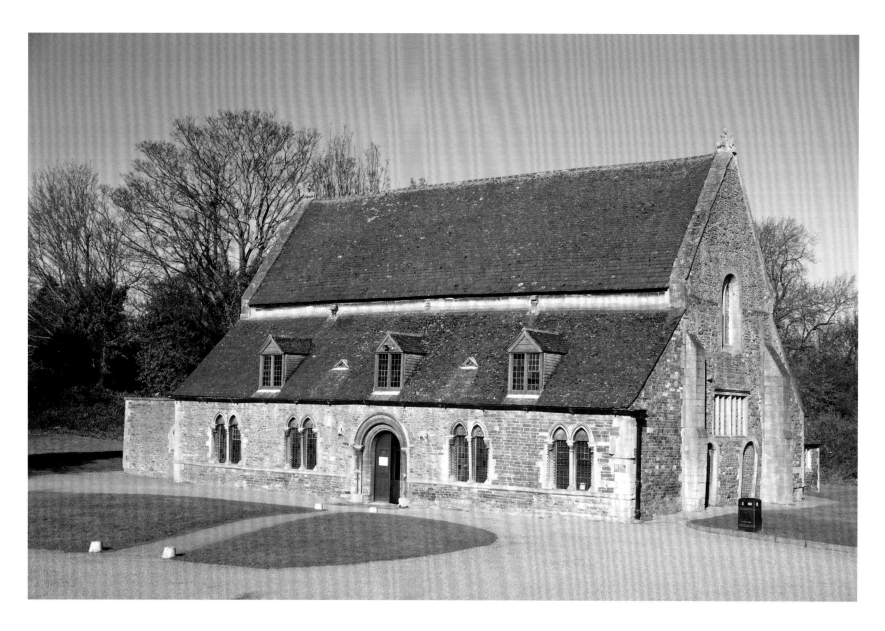

ABOVE Oakham Castle is the great hall of a substantially fortified manor house built for Walkelin Ferrers around 1180–90. It is probably one of the finest examples of domestic Norman architecture in the country and certainly the earliest surviving example of an aisled stone hall. High earth banks still encircle the site in the manner of a Norman motte and bailey style fortification and at the time of its construction, that defensive perimeter was augmented and strengthened by several watchtowers. The castle was the seat of the lords of the manor of Oakham but as was customary with most medieval manors, occasionally reverted to the Crown as result of forfeiture through misdemeanour or a holder perhaps dying without any apparent heirs. By the early sixteenth century many of the buildings had fallen into decay but the hall itself remained in good condition, due in part to the fact that it served as a courtroom for both Oakham and the county, with Assize courts continuing to be held there until the 1970s.

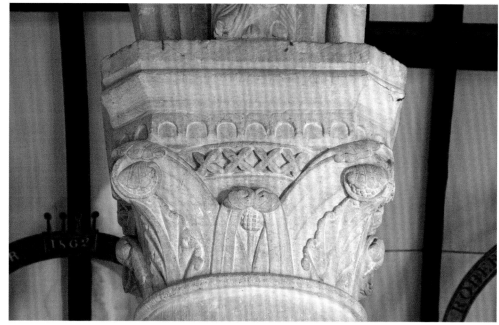

RIGHT Despite having an outstanding architectural history, Oakham Castle will always be better known for the bizarre collection of over 200 horseshoes of varying sizes adorning its walls. Some are patently normal iron shoes taken straight from the animal's hoof but many are large, gilded more ceremonial specimens. The unique custom instigated at Oakham demanded that peers of the realm visiting Rutland for the first time should present a horseshoe to the lord of manor or face having a fine levied against them. The oldest surviving example is the one presented by Edward IV in 1470 after his victory at the Battle of Losecoat Field near Empingham and although many are comparatively modest in size, the one presented by George IV now hanging on the west wall dwarfs all around it. From the end of the eighteenth century, it became customary for the horseshoes to bear a coronet appropriate to the peer's rank which in descending order is Duke, Marquis, Earl, Viscount and finally Baron.

LEFT The exquisitely sculpted twelfth century Romanesque capitals of Oakham Castle are undoubtedly the building's most notable architectural feature. The quality of the craftsmanship is of the highest order and in both design and the style of carving, virtually identical to those found in the choir of Canterbury Cathedral. As the work on both buildings dates from the 1180s, it is not unreasonable to surmise that masons under the cathedral's chief architect, William of Sens, were also responsible for executing the Oakham commission.

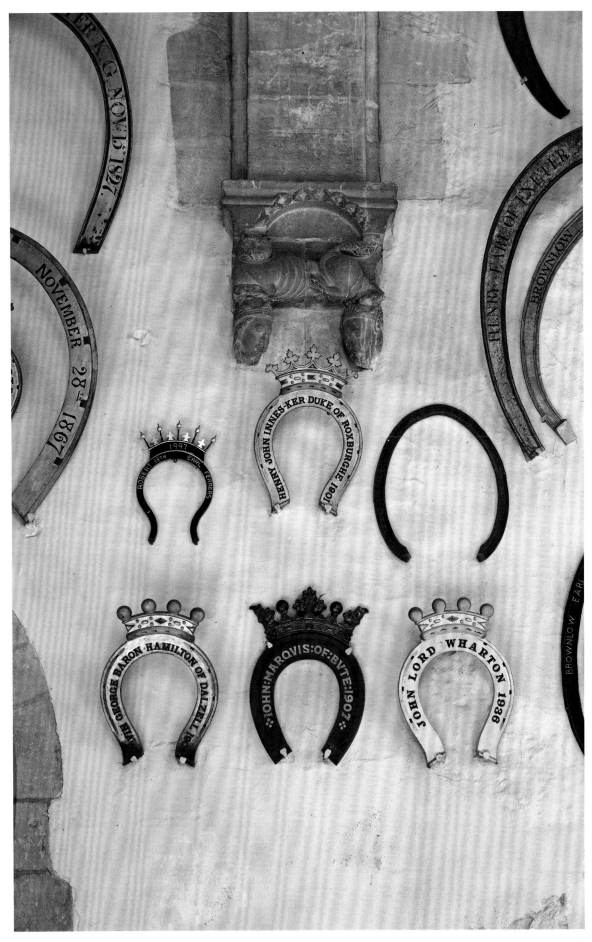

LEFT The original Oakham School building still stands in a secluded corner of All Saints' Church yard. Its walls bear inscriptions in Hebrew, Greek and Latin, the only subjects taught to the first scholars in the Oakham and Uppingham schools, founded jointly in 1584 by Robert Johnson (1585–1625) the rector of North Luffenham. He was also Archdeacon of Leicester and held other church posts at the same time. As they were all paid positions, Johnson accumulated considerable wealth, enabling him to establish the two educational institutions. Oakham School continued in that one classroom for several centuries but with fluctuating success, and records show that in 1875, the register contained the names of just four boys, two of whom were boarders. As the nineteenth century drew to a close pupil numbers increased but never sufficiently to render the school a viable educational establishment able to sustain the original aspirations of its founder.

RIGHT ABOVE The main building of Oakham School now stands immediately behind the ancient butter cross in the market square and on the opposite side of the parish church to its more humble predecessor. The school's regeneration began with an application to the local authority for a Direct Grant to become a grammar school. With that financial stability and local government support things improved. Pupil numbers rose once more and an expansion programme resulted in new school buildings and boarding houses. Oakham continued to thrive and progress onwards through the twentieth century until opting to become fully independent from the local authority in 1970 and co-educational the following year. Oakham is now firmly established as one England's leading co-educational public schools with over 1,000 pupils.

LEFT AND ABOVE Oakham's Grade I Listed Butter Cross stands immediately in front of Oakham School, tucked away in a small cobbled triangle just off the main market square and probably dates back to either the late sixteenth or early seventeenth century. This hugely imposing octagonal structure, some 36 feet in diameter, comprises a steep pitched stone slate roof supported by a massive central stone pier and eight outer wooden posts supported on stone blocks. The octagonal central shaft stands on three steps, the lower of which also served as seats for the curiously five-holed stocks. Smaller versions in rural villages might have had just two holes, the norm usually four but Oakham seems to made provision for shackling an odd number of limbs. Not all petty crime resulted in a spell in the stocks but justice on market days was commonly administered by courts of Pie-Powder, (derived from the French for dusty feet *pieds poudre*) enabling any complaints relating to travellers or itinerant merchants to be dealt with on the same day.

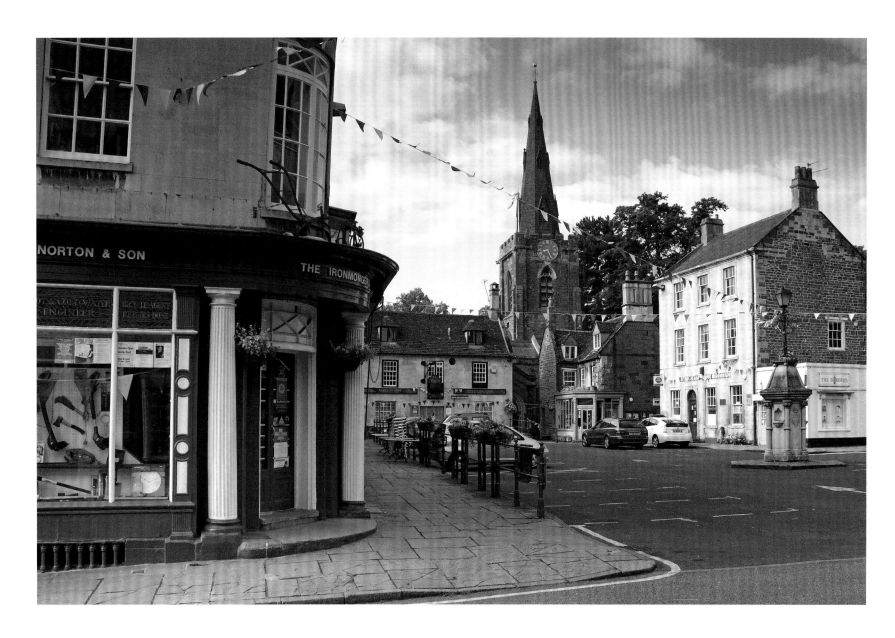

ABOVE Uppingham is Rutland's second town and located just six miles to the south of Oakham. It was built on a ridge running from east to west with a skyline dominated by the church of St Peter and St Paul and the buildings of Uppingham School. With the exception of the predominantly fourteenth century church and the original school building still preserved in the churchyard, no buildings of great antiquity survive. Edward I granted a charter to the Lord of the Manor, Peter de Montfort in 1281 and Uppingham still holds a weekly market in the small square set between the High Street and parish church. Old maps of the town reflect its former importance as a trading centre through names such as Beast Hill, the site of a former cattle market, and Hog Hill where pigs were sold. Prior to the town being by-passed in 1982, Uppingham suffered the same chaos experienced by many of England's smaller market towns similarly located on main trunk roads and whose layout was unable to cope with the sheer size, weight and volume of traffic that is the norm today.

RIGHT The impressive Victoria Tower built by the architect, Sir Thomas Jackson, between 1894–7, is the main entrance portal to Uppingham School and just one of several equally imposing buildings added during a period of growth and expansion during the nineteenth century. A very different scene was encountered by Uppingham's most influential headmaster, Edward Thring (1821–87) upon taking up his post in 1854, finding just twenty five pupils on the school register. Since its foundation almost three centuries earlier, the school was poorly endowed, had inadequate buildings and was known only within the immediate locality. Thring transformed the fortunes of the school and introduced radical changes to the academic curriculum but perhaps his most important philosophy was that pupils should be treated as individuals with their own particular talents, rather than a group of automatons to be force fed facts, figures and Latin declensions! That ethos spread to many other public schools and the legacy of Thring's pioneering innovation is apparent in the numbers of old scholars who have achieved excellence and worldwide fame in business, politics, entertainment and sport.

ABOVE Uppingham and Oakham public schools share the same founder, Robert Johnson, and the original classroom buildings of both institutions still stand in their respective town's churchyards. In the pre-Reformation era, education and the church were inevitably closely linked because in medieval England, literacy was the almost exclusive preserve of monastic institutions and it was in the cloisters that the children of royalty and nobility were privately educated. The development of grammar schools began when John Colet, dean of St Paul's Cathedral, founded St Paul's School in 1509, an instigation continued by Henry VIII and his successor, Edward VI, whose secular foundations replaced the cathedral schools of the dissolved monasteries. Many of England's famous institutions such as Harrow, Rugby and Uppingham all began as grammar schools in Tudor England, offering free education to local boys but with fees charged to boarders and although Johnson's private financial means had been sufficient to establish the school, its fortunes fluctuated considerably during the ensuing centuries.

BELOW Forest Books and its near neighbour on High Street West, the Rutland Book Shop both lie in wait to entrap unwary visitors sauntering towards Uppingham School. It is virtually impossible to pass by their beguiling window displays of rare secondhand books without venturing inside. In an era ever more dominated by electronic and computer generated media, it is so refreshing to be able to browse through the specialist or quirky collections housed in these second-hand bookshops. However, it is ironic to also realise that many such establishments would probably not survive in the prevailing economic climate were it not for the internet allowing their wares to be viewed and purchased by collectors from all corners of Britain and beyond.

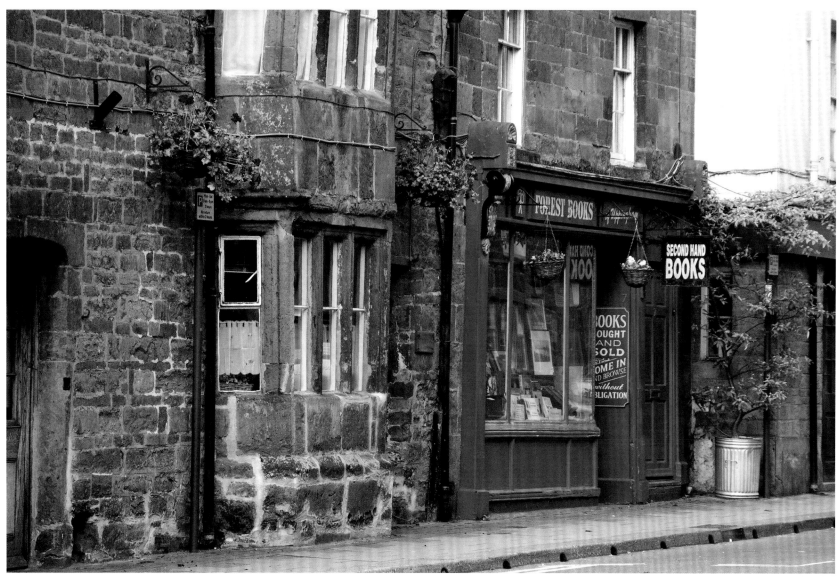

LEFT Uppingham's elevated location is perfectly highlighted by the steepness of Scale Hill and the manner in which the few houses and buildings standing just below the perimeter wall of the school appear to plummet out of view. Scale Hill forms the initial section of London Road and although modern vehicles have little trouble in negotiating the steep incline, except perhaps under extreme winter conditions, eighteenth century horse-drawn coaches fared less well. The coaching era as portrayed on countless Christmas cards may be tinged with an aura of romanticism but on hills such as this with no feasible detour, passengers would have been asked to lighten the load by alighting and walking behind the coach up frequently muddy, rutted tracks. Happily, there was a viable detour into the heart of Uppingham, thereby ensuring that travellers did not arrive dishevelled and caked in dirt.

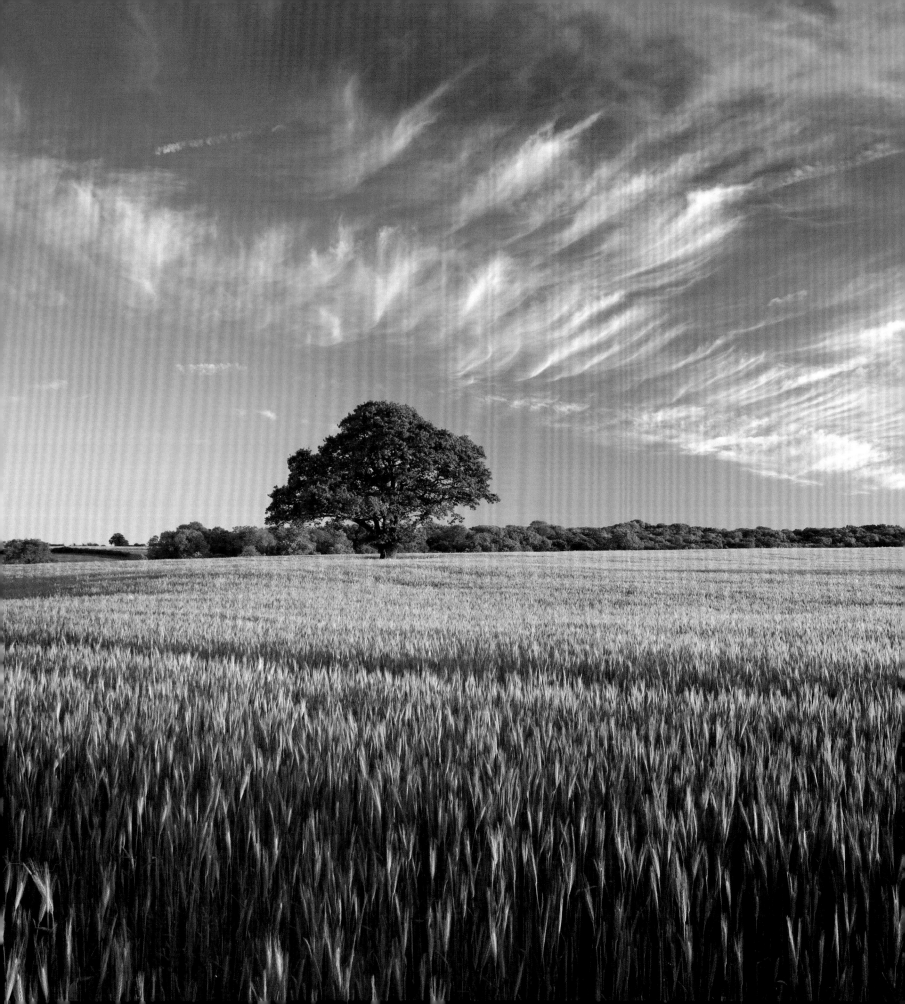

summer

LEFT A field of barley near Stoke Dry shimmering in the gentle breeze of a summer evening and set against a backdrop of a delicate cloudscape. It is rewarding to be in the right place at the right time when nature does decide to co-operate and put on a bit of a show. Scenes such as this really are the epitome of the English countryside and although one accepts the general arguments in favour of 'green' energy, how pastorally sublime would this image be with three giant wind turbines poking above the horizon?

OVERLEAF A field of poppies and rapeseed overlooking the village of Ryhall and the parish church of St John the Evangelist. Poppies en masse have become such a rarity in the countryside that I was taken aback to see an entire field of red blooms, especially when mixed in with the equally vivid yellow rapeseed flowers. The poppy may be our national symbol of Remembrance, but to cereal farmers it is an intrusive weed with a highly efficient seed distribution system that is difficult to eradicate.

The summer months are a busy time for everybody in those rural communities of Rutland engaged in farming, commercial horticulture or simply gardening for pleasure. This is the season when daylight hours increase and temperatures rise, encouraging the rapid growth of both natural and cultivated plant and animal life. Once the garish slashes of yellow rapeseed flowers have disappeared, the colours of the countryside resume their customary schedule of gradual transition from fresh spring green through to the mellow gold of ripening fields of cereals. During early June, many people from Rutland and further afield make an annual pilgrimage to Burley-on-the-Hill for the county show, one of the earliest in England's calendar of livestock, equestrian and country events.

Although the increasing popularity of Rutland Water draws ever more visitors to its shores for the water sports and other leisure pursuits that have been developed since its creation, the county as a whole has happily not been affected by the mass summer influx that has blighted other destinations. It has always been one of the conundrums of tourism that as soon as somewhere becomes admired for its rural beauty and tranquillity, everybody wants to enjoy that ambiance and it soon ceases to be the haven that proved so irresistible in the first place. There is little danger that such a fate will befall Rutland in the foreseeable future and anyone venturing out amidst its quiet country lanes and villages will be able to savour the true beauty of the English countryside. This is an enchanting place where birdsong is not drowned out by incessant traffic noise, fast food eateries do not generate mountains of litter and where nature goes about its business in much the same untroubled way it has always done.

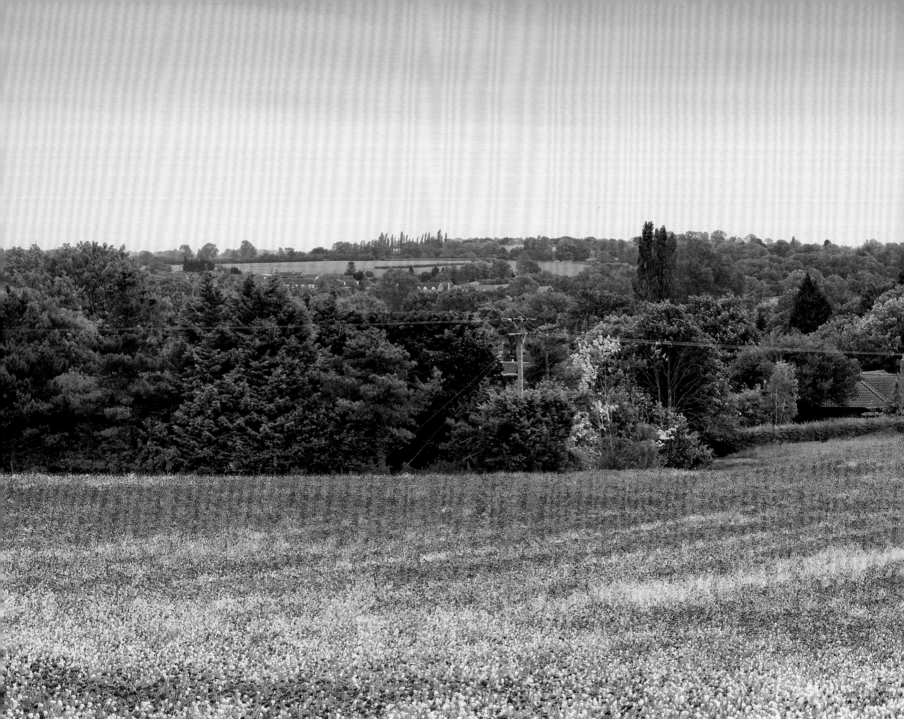

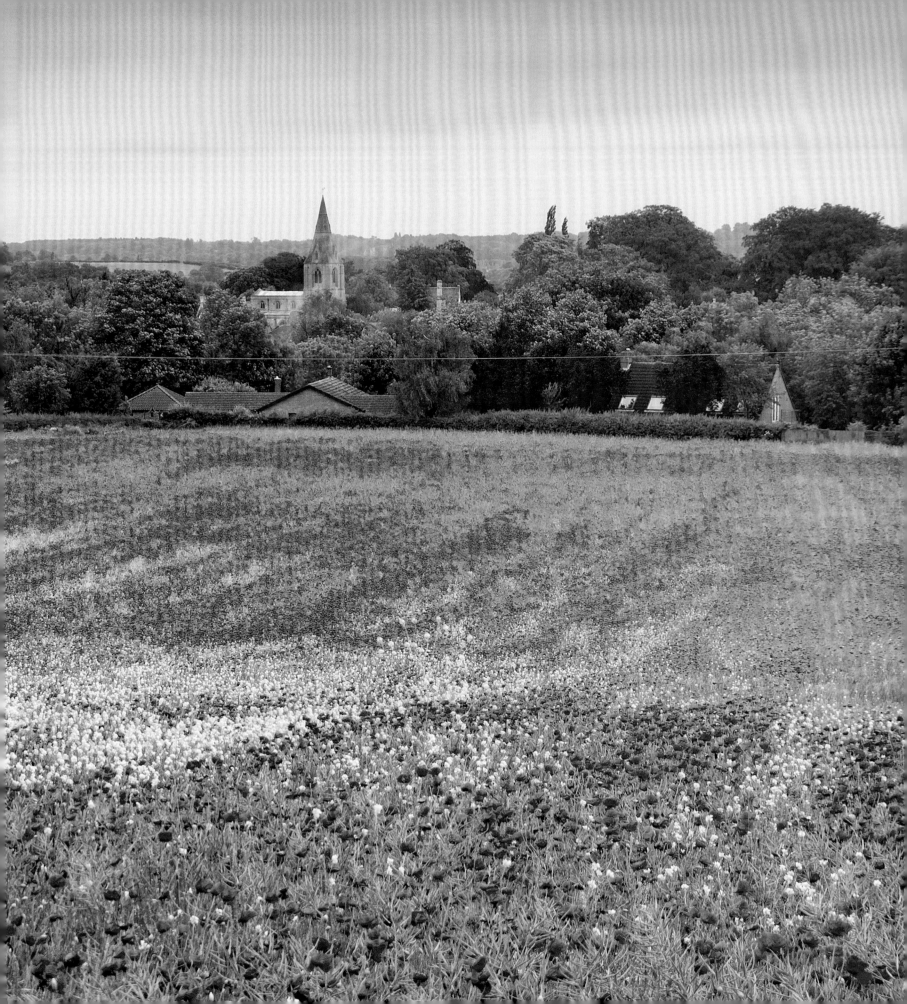

BELOW Rutland County Show is an important date in the county's annual calendar of events, attracting both local exhibitors and livestock breeders from further afield. The main cattle show rings are overlooked by the historic buildings of Burley Hall and it would be hard to devise a better setting for a truly English event.

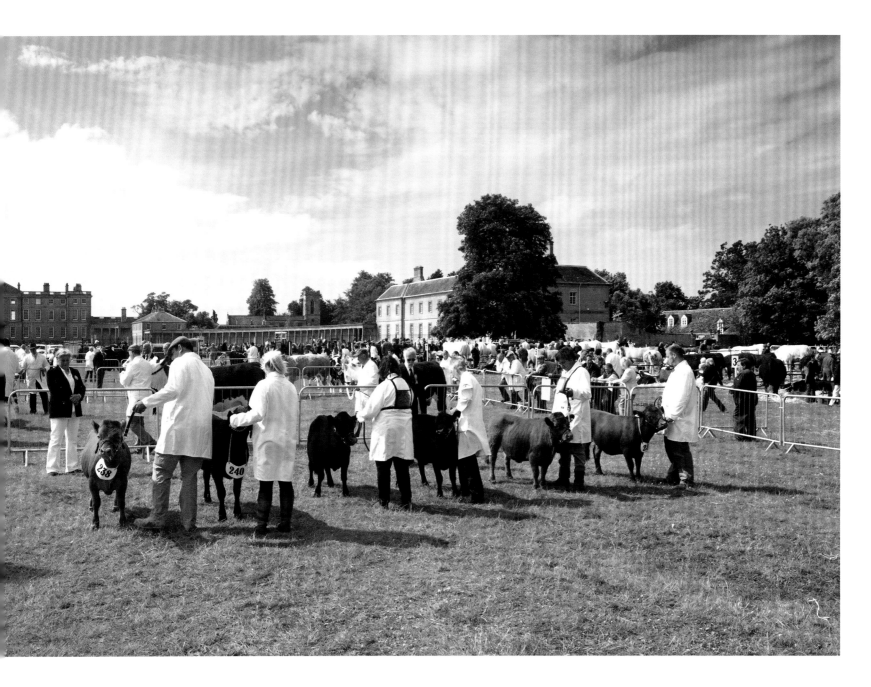

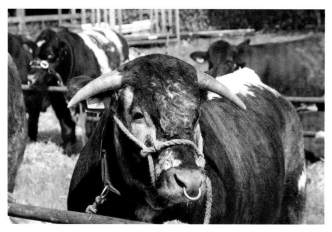

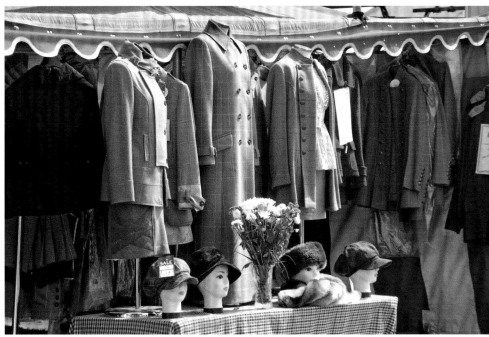

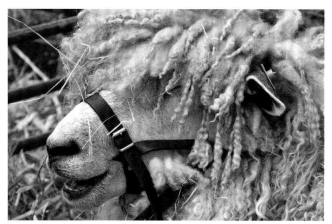

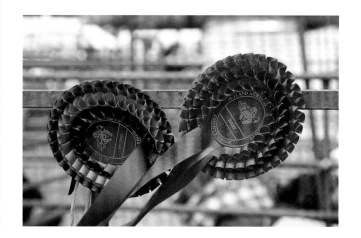

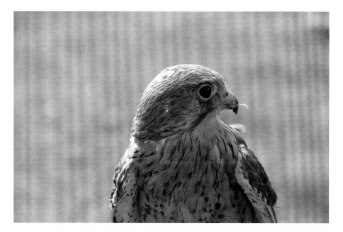

TOP A vintage car and agricultural machinery display

ABOVE A country clothing stand

RIGHT, TOP TO BOTTOM English Longhorn cattle, Leicester Longwool sheep, show rosettes, American Kestrel

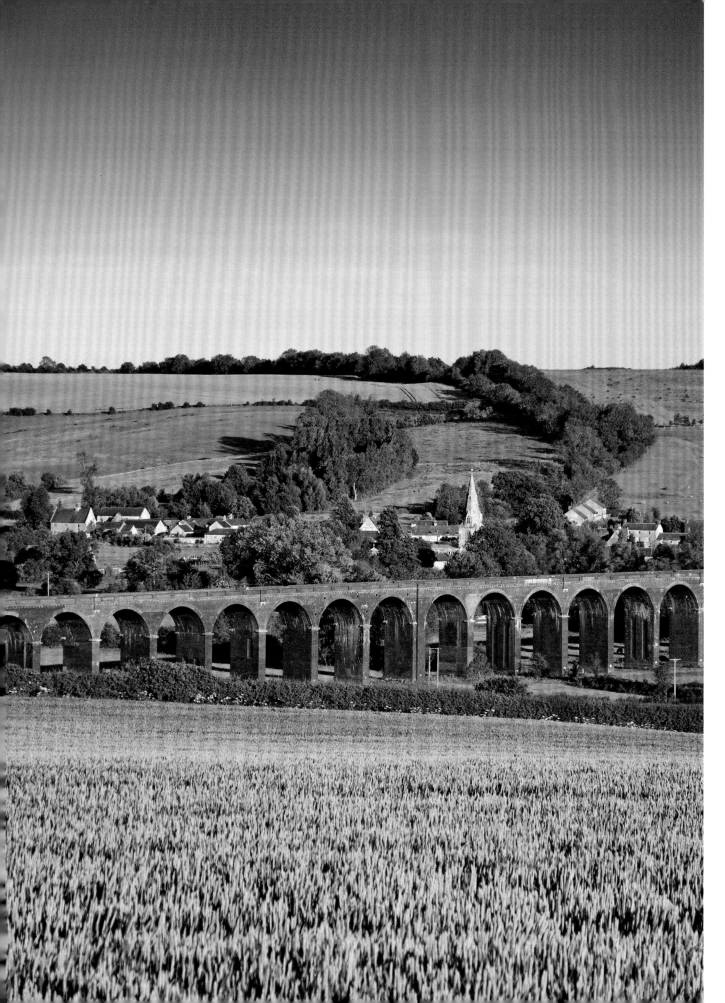

LEFT The 82-arched Welland Viaduct crosses the River Welland on the Rutland Northamptonshire border and is also often referred to as either the Harringworth or Seaton Viaduct after the two nearest villages (the former featured in this picture). It was yet another extraordinary feat of Victorian engineering in an age where anything and everything was deemed possible. At over 1,110 metres in length, the viaduct is the longest structure of its type on the British rail network and yet was built in the astonishingly short time of two years with the final bricks being laid in 1878. The elements have inevitably degraded the structure over time but a concerted restoration programme using more weather resistant materials has ensured the viaduct's continued survival.

RIGHT ABOVE The gaunt, skeletal shell of a mid-nineteenth century windmill near South Luffenham. The mill was perfectly located on an exposed ridge of high ground to ensure that every available breath of wind would be caught in its sails.

RIGHT BELOW A medieval bridge over the River Welland at Duddington crossing from Northamptonshire into Rutland (or vice versa!).

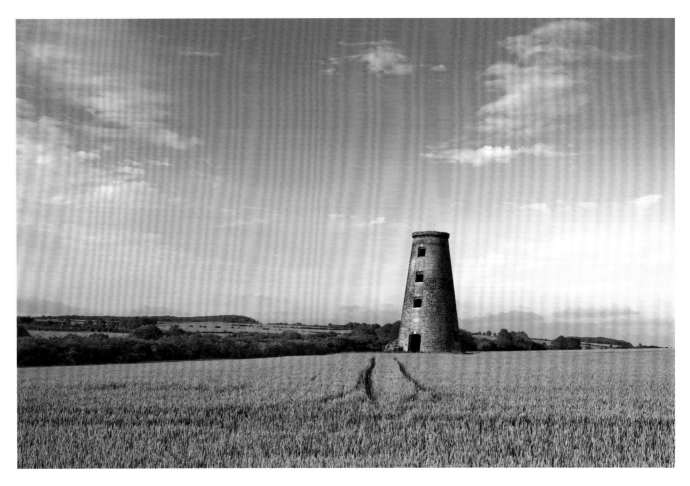

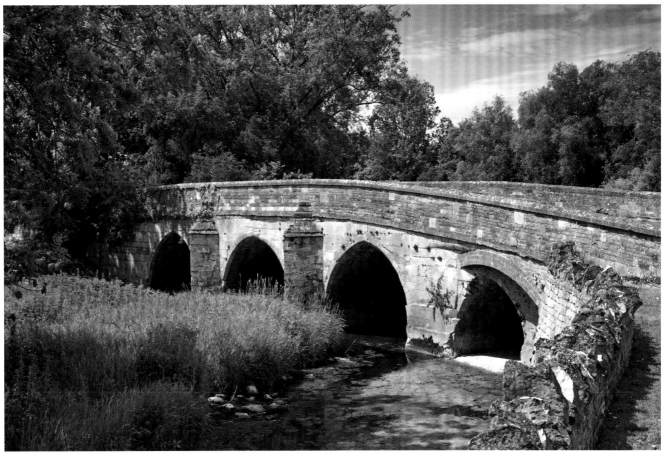

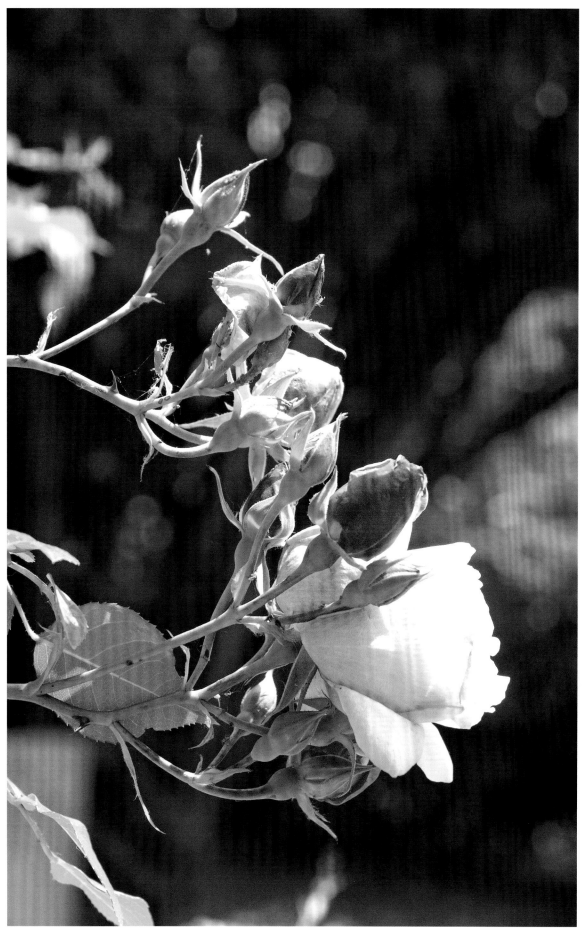

LEFT Scented roses in a Rutland churchyard

OPPOSITE, CLOCKWISE FROM TOP LEFT Thistle down, apple blossom, blackberry flowers, pink campion

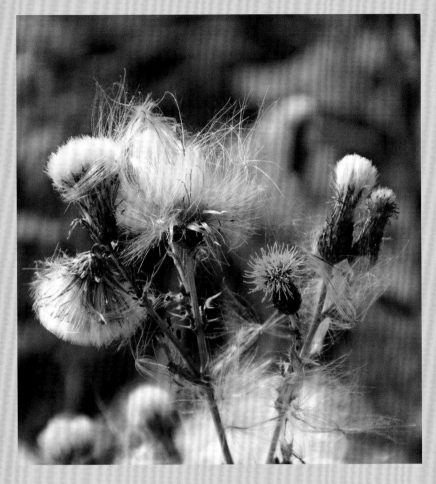

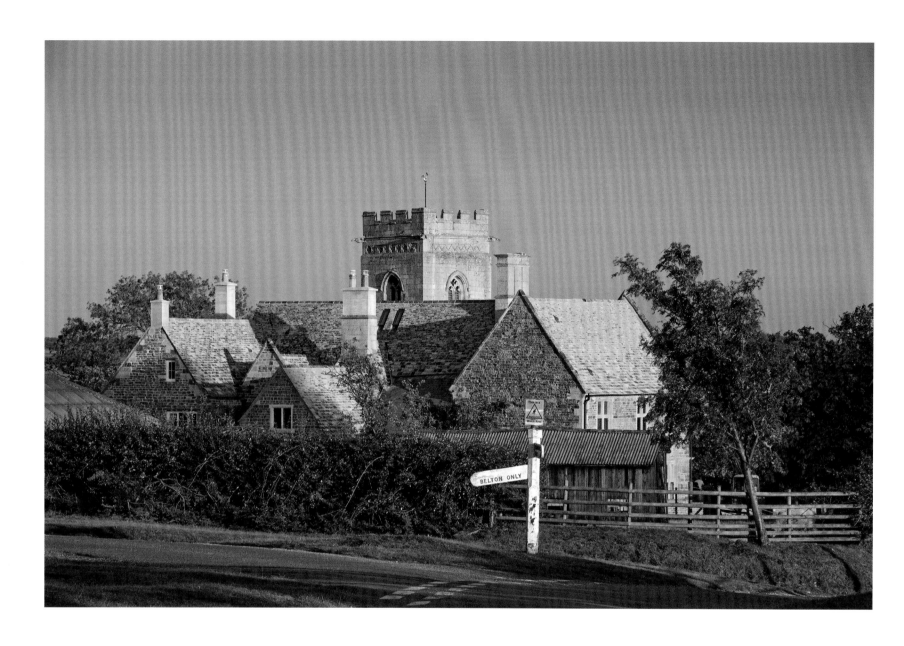

ABOVE The Old Hall and St Peter's church, Belton-in-Rutland at sunset. The busy A47 road is only a few hundred metres away but the narrow lanes around this village are seldom troubled by through traffic.

ABOVE The Eyebrook Reservoir at sunset on this warm summer evening was not the place to be for anyone with an aversion to flying insects. The sheer density of the swarms of mosquitoes and other winged creatures was an extraordinary sight and sound and although I could feel myself being rapidly eaten alive by the voracious hordes, it was a photographic opportunity not to be missed.

BELOW This bridle track running down to the River Welland must once have been a major link between Rutland and Northamptonshire as there is actually a Rutland county boundary sign near the river, the type one normally encounters on tarmac roads. The ancient bridle path joins up with The Jurassic Way, a long distance footpath that runs for 88 miles along a limestone ridge between Banbury and Stamford.

OPPOSITE ABOVE Advances in technology may have transformed tractor and combine harvesters into state of the art machines equipped with GPS navigation and sound systems but the harvesting process nevertheless remains a long, dusty and tedious task. During the long, dry days of late summer, the drone of the combines can be heard from dawn until dusk and often well into the night.

OPPOSITE BELOW This golden cathedral of straw bales near Seaton contrasts sharply with the rich brown soil of fields from which the harvest was garnered, already ploughed and prepared for the next phase of the year-round farming cycle.

OVERLEAF High summer in the Vale of Catmose between Oakham and Uppingham.

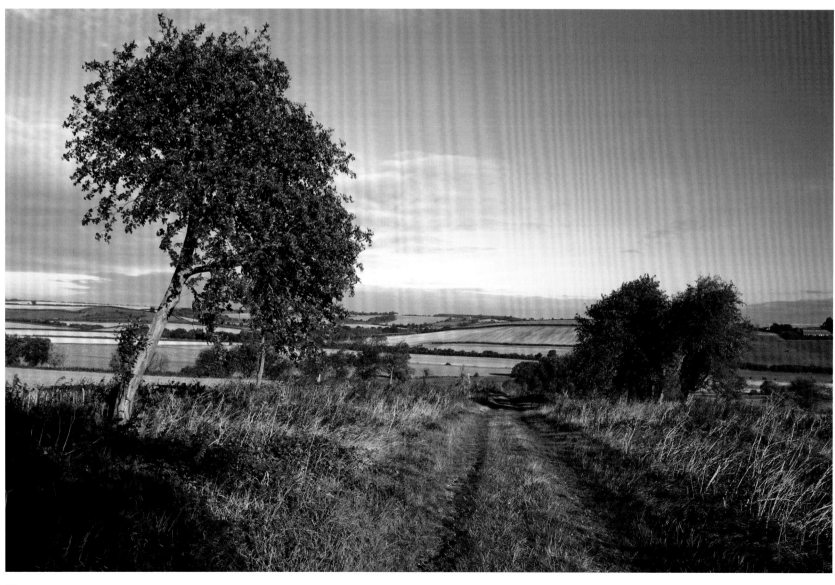

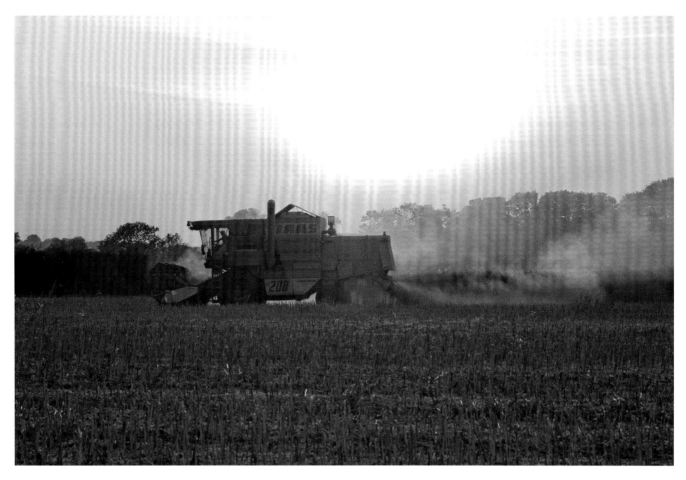

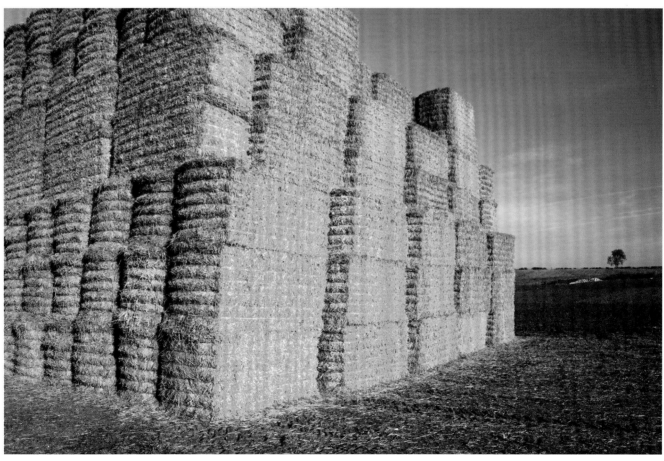

architectural heritage

People wax lyrical about the honey coloured villages of the Cotswolds but anyone wishing to savour outstanding examples of England's built heritage need not endure villages whose streets are now blighted by double yellow lines and the ubiquitous Pay & Display car parks. Rutland's landscape cannot always match the drama of the Cotswolds but much of its vernacular architecture compares most favourably and it is a joy to be able to potter from village to village on virtually deserted country lanes.

Protecting, conserving and understanding the nation's precious architectural heritage is just one of the roles undertaken by English Heritage through the Listed Building Register. The most important buildings or structures of exceptional national interest are awarded Grade I status, Grade II* denotes an importance that is significantly more than special interest but the majority of listings fall into the lowest Grade II category, defined as being of 'special interest, warranting every effort to preserve them.' Rutland has twenty eight Grade I listed buildings, sixty nine Grade II* and some 1,400 within the Grade II category. A listed building designation frequently applies to a group of buildings rather than a single property, an important factor within the context of English villages. It is not only houses and buildings that are afforded listed protection, many details such as tombstones, walls, gateposts, village pumps and stocks are included on the list. For those who own a listed building, having to adhere to additional planning guidelines and restrictions governing even the most minor alterations may seem onerous but with every passing year, the fragile fabric of our built heritage weakens and it would be nice to think that we can pass on more than nostalgic photographs to future generations.

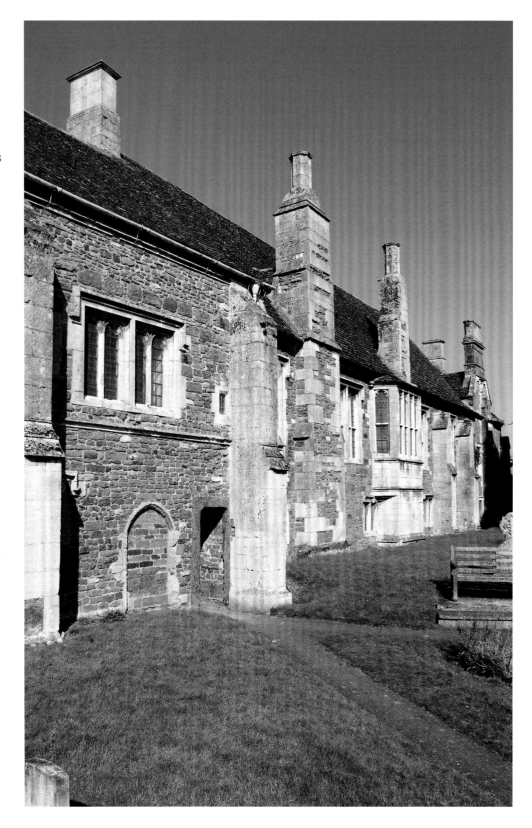

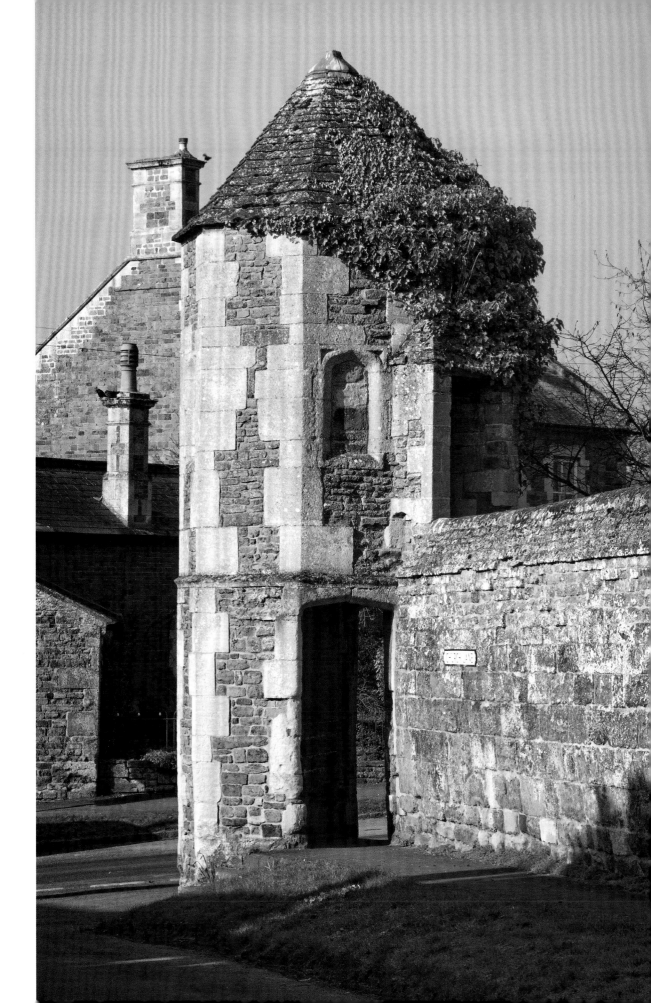

LEFT The Bede House stands adjacent to the church of St Andrew and was created from a surviving wing of the medieval bishop's palace. Bede houses were almshouses run to a strict set of rules and those at Lyddington were founded during the early seventeenth century by Sir Thomas Cecil, 1st Earl of Exeter (1542–1623). The Bede House was initially established as the Jesus Hospital for the benefit of twelve poor men, two women and a warden. The terms and conditions of acceptance stated that applicants should be 'free of leprosy, lunacy and the French pox,' a phrase commonly used during that period when referring to syphilis. Substantial remodelling of the original structure was required to enable each room to be fitted with its own fireplace and a small window. The Bede House was finally abandoned in the 1930s and left to decay until being rescued and gradually restored. It is now in the care of English Heritage and open to the public.

RIGHT The late fifteenth century Watch Tower was originally part of the defensive perimeter walls surrounding the medieval Episcopal palace built for the bishops of Lincoln. In purely military terms, the tower was perhaps little more than a token gesture but would have been adequate to deter opportunist crime and protect the bishop and his staff during any civil unrest. This Grade I listed structure is built of coursed ironstone rubble and bears the arms of John Russell, Bishop of Lincoln from 1480–94. This two-storey tower, Lyddington's magnificent church and adjacent Bede House form one of the finest groupings of historical buildings in Rutland.

Despite being somewhat hemmed in by the modern housing developments creeping ever further out from the village centre, Whissendine windmill soars defiantly above the roof tops. The mill was originally built in 1809 by the Earls of Harborough who owned nearby Stapleford Park and the manor of Whissendine. It changed ownership several times during the next hundred years but was eventually forced to close after seemingly irreparable damage by a storm in 1922. Its current owner, Nigel Moon, bought the mill in 1995 and has painstakingly restored it to full working order, grinding grain under wind power again as it had done some two centuries ago. An electric motor was used to turn the grinding wheels until the sails were once again fully functional and with that aid at his disposal, the miller need not fear being becalmed in a protracted spell of idyllic weather. An average week's grinding will produce up to 2 tonnes of high quality flour, much sought after by local organic food stores and the ever growing numbers of artisan bakers on a crusade to bring proper bread back to the table.

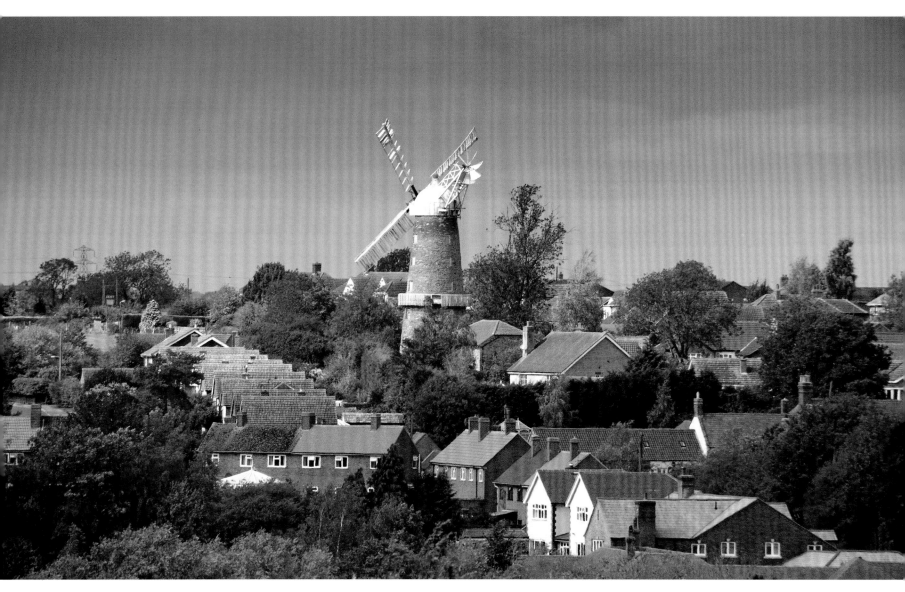

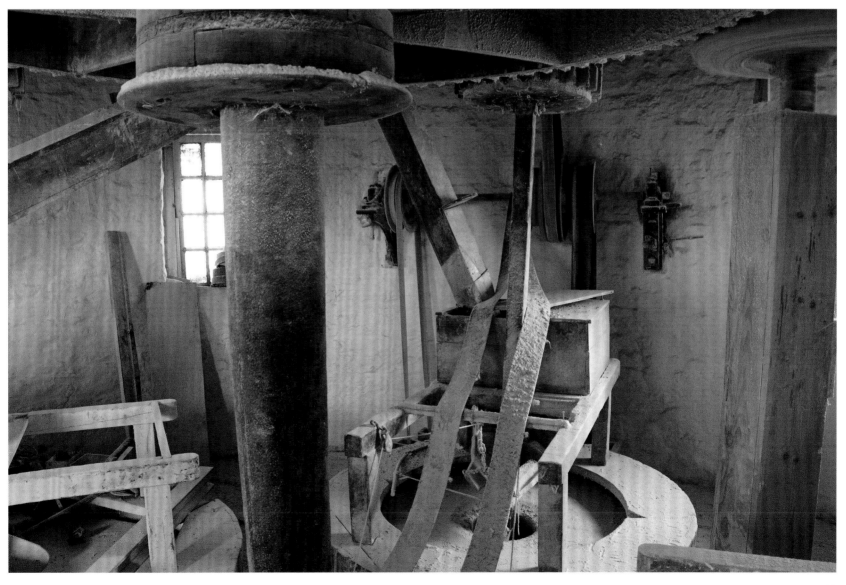

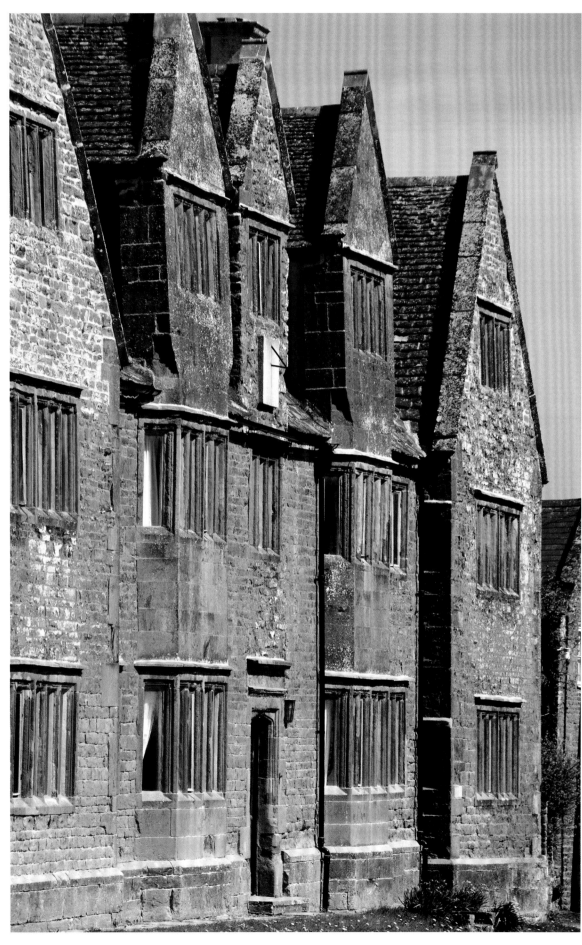

LEFT Preston is a delightful village of particularly rich-coloured ironstone buildings, the best examples of which are located on Main Street and Cross Street. Thirty of Preston's thirty three entries on the Listed Building Register are Grade II and of the remaining trio awarded the accolade of a starred listing, my personal favourite has to be the old Manor House. A significant proportion of Rutland's finest old houses are either secreted away down long access drives or hidden from view by walls, trees and foliage but the magnificent tall, pointed gables of the Manor House face directly onto Cross Street. Discretion is paramount when studying the exterior of an historic building that also happens to be a private dwelling as it must be irksome in the extreme to have one's privacy constantly invaded by the persistent stares of insensitive tourists. Although the house does have noteworthy details such as an imposing studded front door with a sundial set high above and symmetrical sets of mullioned windows, the design and construction of this typical Elizabethan mansion can be more fully appreciated from distance.

RIGHT The group of Grade II listed thatched cottages on Exton's High Street lying to the north of the village green, are very good examples of dormer windows. The dormer ridge begins some way up the roof and is then sculpted and moulded by the thatcher into a deep, protective shell around each window. The deep sides are referred to as cheeks and these deep dormers render windows impervious to virtually any kind of weather except a head on hurricane but there are two readily apparent disadvantages to such a high level of protection. Light penetration through into the room is much reduced and rather like a blinkered racehorse, the only view out of one's already diminutive bedroom window is straight ahead! East Anglian reeds are used for some thatched roofs but long straw seems to be the material now most favoured by thatchers. Straw thatched roofs are so efficient that that roof spaces seldom need additional loft insulation, a factor less applicable to reeds.

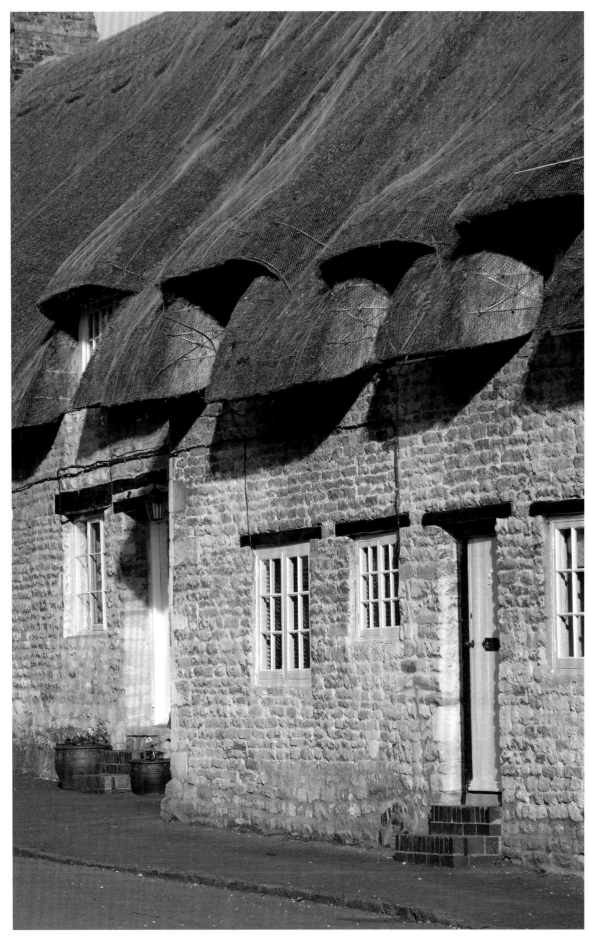

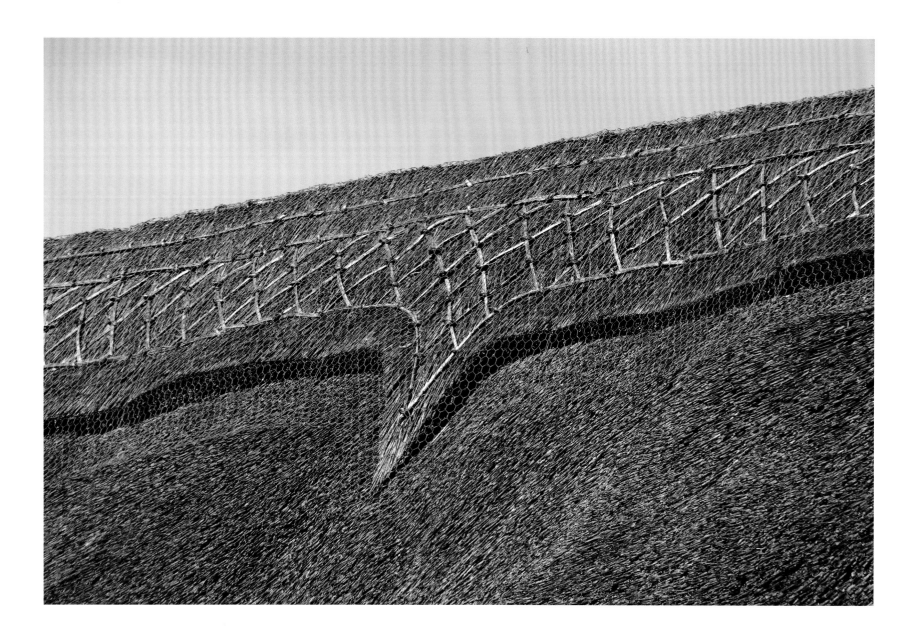

ABOVE In villages where thatch is the predominant material, one seldom encounters identical roofs because although the techniques employed for securing thatch onto the roof timbers and around gable ends, windows and chimneys are fairly standardised, it is the creative input by each thatcher that sets them apart. Roof ridges are often the place on a roof where one encounters the most elaborate decorative detail, especially when block ridges are used. A block ridge is one on which straw is built up into a block above the roofline and then cut back to make a raised cap along the ridge. This is quite a common way of finishing a roof because the extra layer of straw above the ridge offers greater protection from the elements, but it also means that thatchers can exhibit their true artistry through the manner in which the ridge is sculpted and finished. Almost all thatched roofs will have coverings of wire mesh netting to deter birds from attacking the straw and although noticeable in close-up detail, is seldom a distraction when viewed from street level.

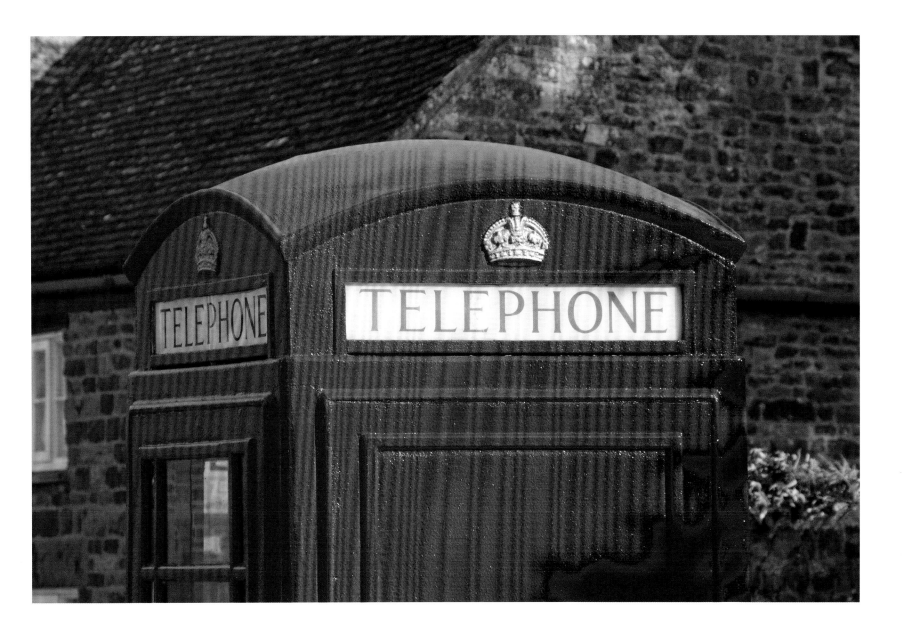

ABOVE The Listed Building Register is not exclusively reserved for bricks, mortar, slate and thatch and one finds many quirky, quintessentially English items amidst the thousands of entries. The K6 model red telephone kiosk is not an uncommon sight in Rutland villages despite being rendered virtually extinct throughout the rest of country. It was designed by Sir Giles Gilbert Scott (1880–1960), the architect also responsible for other iconic English landmark structures, most notably the Anglican Cathedral in Liverpool and Battersea Power Station.

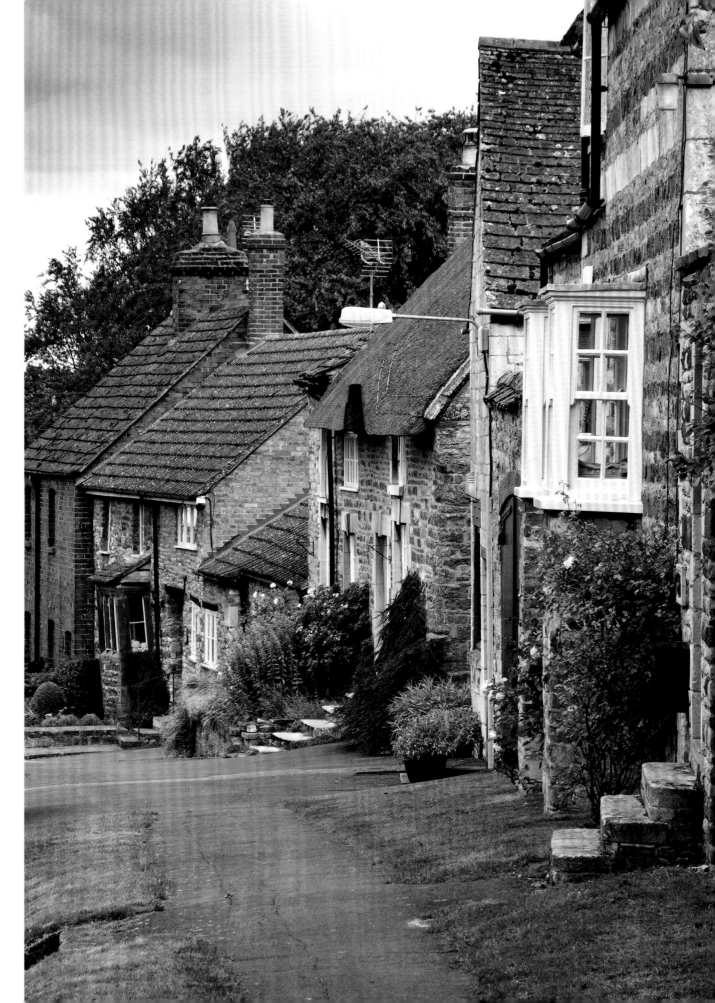

RIGHT Manton's small triangular green at the top of Stocks Hill bears a tree on each of the three corners, but the instrument of punishment after which the road was named has long since disappeared. Stocks Hill slopes gently down to the parish church of St Mary the Virgin and thereafter merges into Priory Lane. Manton suffered a catastrophic fire in 1732 that destroyed many of the oldest houses and so although those running downhill from the green are not of the greatest antiquity, they do highlight how building styles and materials from different centuries can harmoniously blend together in a village setting. One or two of the houses have earlier core fragments but essentially are of either seventeenth or eighteenth century construction with roof covering either of Welsh slate, tile or thatch.

BELOW This row of five Grade II listed cottages on Well Street in Langham highlights how the grouping system of Listed Buildings works. All five dwellings in the terrace are from the early nineteenth century and although similarly constructed from varying shades of ironstone they are patently not of the same build and despite being almost seamlessly welded together, those featured in the photograph could not be more different. The one on the right is built of well dressed stone blocks bedded on thin courses of mortar whereas the left hand cottage has been built from fairly coarse, smaller and misshapen rubble requiring substantial quantities of cement to bind the structure together. Cost has always been a factor in the construction of stone buildings and the contrasting use of materials between the two was probably also a reflection of their respective owner's financial status.

BELOW The old blacksmith's forge in Langham is at the end of the terrace closest to the main road between Oakham and Melton Mowbray, a reminder of the era when people were dependent on horses rather than mechanical horsepower as a means of travelling. The Forge no longer echoes with the constant ringing of hammer on anvil, the clattering of anxious hooves on cobbles but the exterior wall is clad in old horseshoes as a reminder of the trade once plied there.

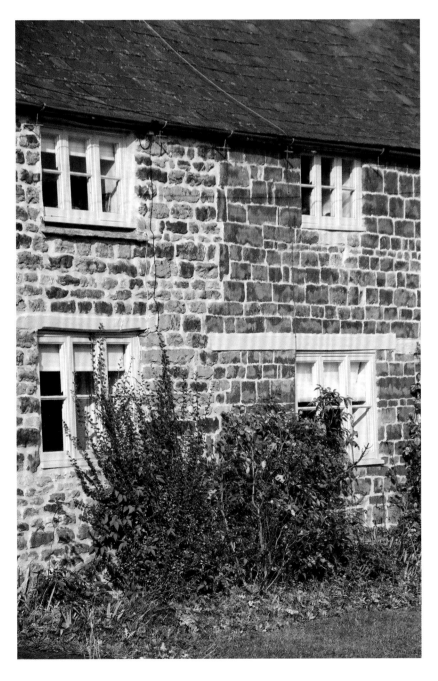

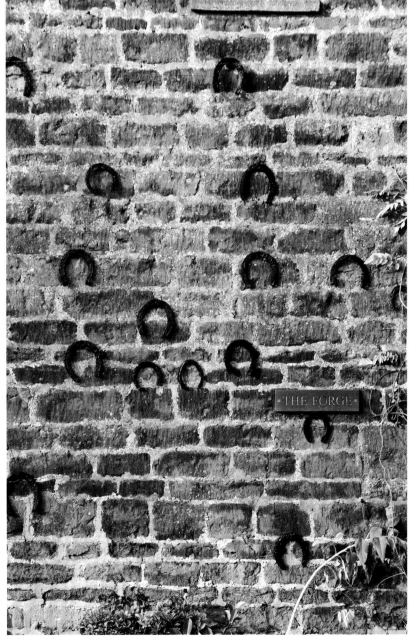

autumn

As the winding down of another year gets under way and most cereal crops have been harvested, Rutland's landscape undergoes a rapid colour change from the ochre and yellows of wheat, barley and oats to the rich browns of freshly ploughed earth. It is fascinating to note how much the shades of brown and the texture of the soils vary from one side of the county to the other, each variation being influenced by the composition of the rock strata lying beneath the surface. Having gathered in the harvest, farmers are busily working and preparing the land in preparation for the next crop. Those who are merely observers of the countryside probably do not realise how much planning has to go into maintaining soil fertility and viable crop yields through careful land management, correct fertilisation and crop rotation.

Nature stages its own final flourish with hips, haws, blackberries and sloes providing much needed food for birds and animals to aid their survival through the inevitable rigours of winter. Those same fruits of the hedgerows are also still appreciated by many living within rural communities where the tradition of home preserving, bottling and jam making continues and is viewed as an anticipated annual ritual rather than a chore to be endured with the results infinitely preferable to supermarket jam!

As autumn progresses, mornings start to get colder and with those changes in temperature come early morning mists that swirl and eddy around valley bottoms until being dispersed by the warmth of the rising sun. That transient phenomenon endows the countryside with a mystique that is a joy to behold (and photograph), especially when the trees hauntingly rising above the mists are themselves becoming tinted with the colours of autumn.

RIGHT The great mound of Rutland Water's dam near Empingham offers a superb elevated vantage point from which to photograph the reservoir and surrounding countryside. Height is one of the most important considerations when photographing misty autumn mornings because if one is too close to ground level, the pictures have little depth and can turn out just looking foggy!

OVERLEAF The acreage of even the largest individual fields in Rutland may not be large when compared to some of the 'prairie farms' in neighbouring counties but this photograph of a tractor and seed drill in operation near Ryhall nevertheless still highlights the contrast between the vastness of the landscape and the comparative insignificance of our presence upon it.

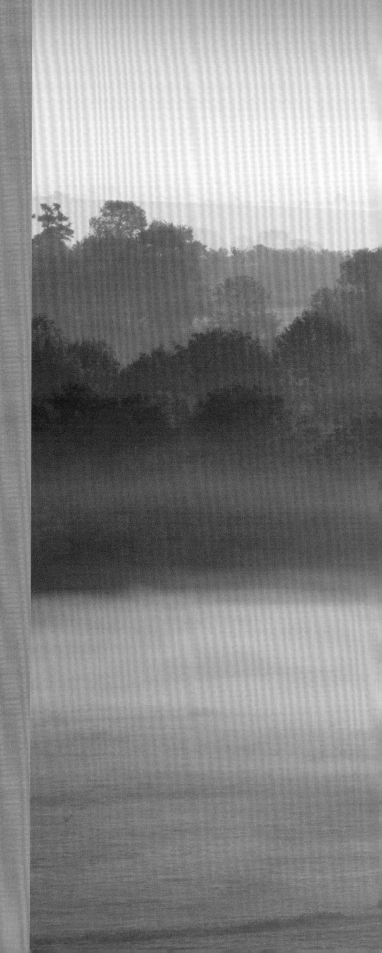

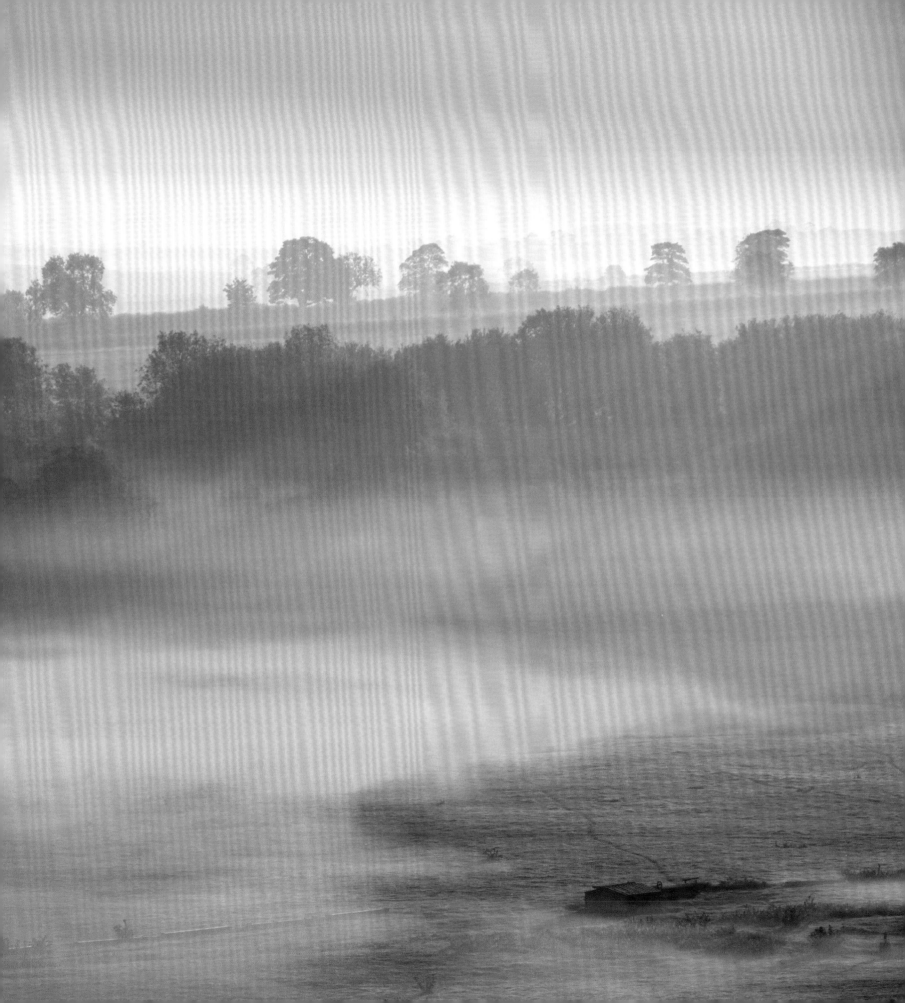

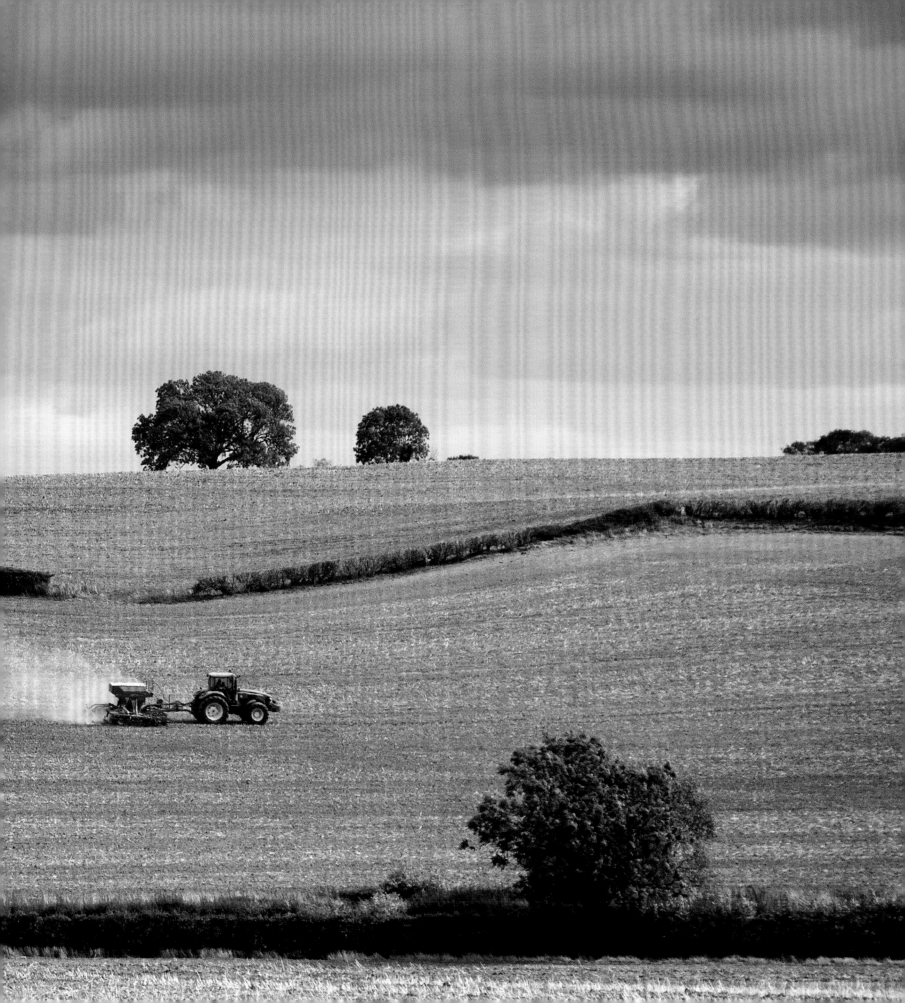

RIGHT The Rutland Morris Men relaxing after a late autumn performance outside the Green Dragon in Ryhall. This group was formed during the 1970s at a time when there was a particular national resurgence of interest in British folk music and traditional customs, a movement that happily continues to thrive in the twenty first century. Those who ridicule grown men for 'dancing around with bells on their legs' are completely missing the point; this is as much a part of our national heritage as a Grade II listed building and we should be thankful that there are still enthusiasts willing to carry on these centuries-old traditions.

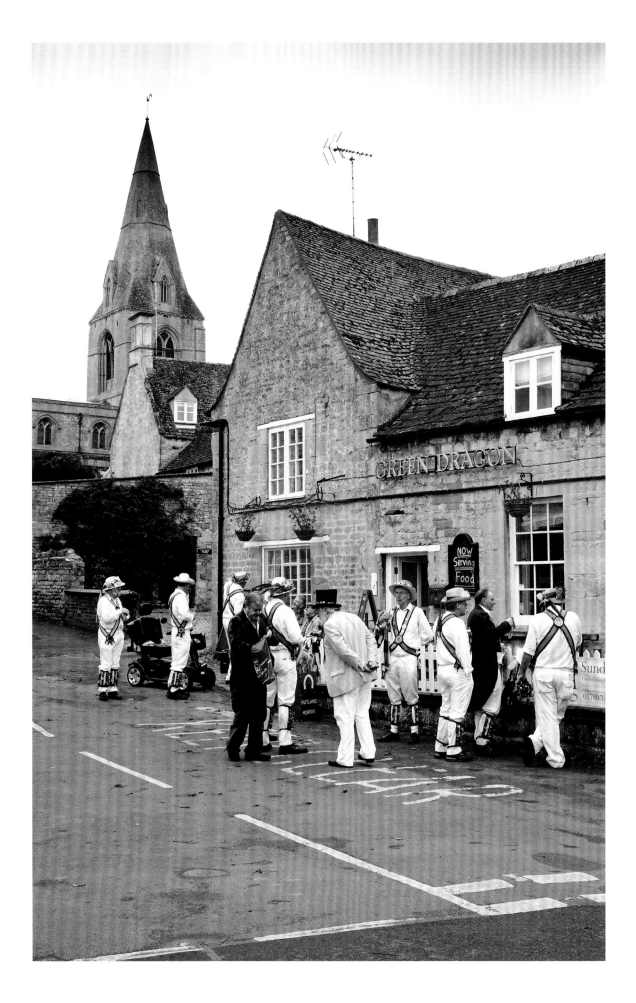

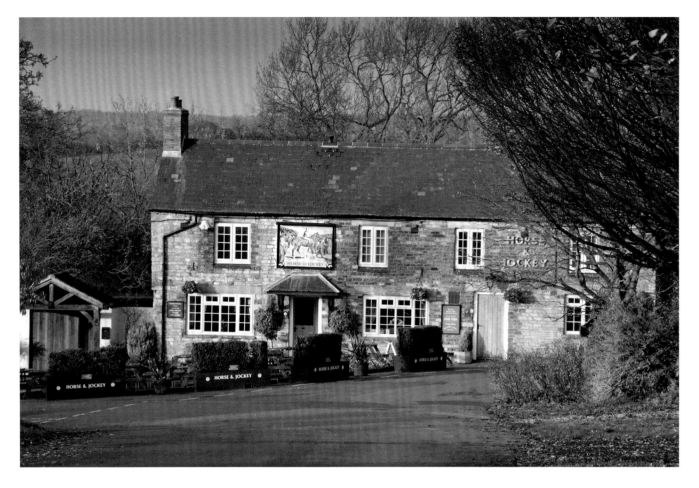

LEFT ABOVE Rutland's long-standing association with equestrianism is reflected in the names of several pubs throughout the county. The Horse and Jockey at Manton is a converted seventeenth century house located on the western edge of this charming village and although now renowned for its food, many outdoor enthusiasts might suggest that the pub's most important attribute is the fact that it is the only one located on the 23 mile cycleway around Rutland Water.

LEFT BELOW The Fox and Hounds is located on the extensive village green in Exton and has been providing hospitality to local residents and travellers alike since 1840. The inn also provided accommodation for the servants of guests visiting the Earls of Gainsborough at Exton Hall and is now the sole survivor from several alehouses trading in the village during the nineteenth century. Exton has a long association with fox hunting, the nearby Cottesmore Hunt being established by the Noel family in 1732. I am perfectly aware that a great many people are vehemently opposed to the very notion of fox hunting, but whether justified or not, there is something aesthetically beautiful about the colours and sounds of a traditional hunt meet outside a country inn. The village green setting of the Fox and Hounds would be the perfect location and nobody has to follow the pack when it moves off, just head back inside for another glass!

The narrow road linking Seaton and Glaston twists and turns as it descends steeply towards a tiny stream feeding into the River Welland. The high ground on the Seaton side provides a glorious retrospective view of the squat twelfth century tower of St Andrew's, Glaston. Those fields closest to the camera appear as meticulously combed as the hindquarters of a prize pedigree bull about to entire the show ring. Despite the screen of trees around the church and village creating an impression of rural isolation, Glaston lies just two miles to the east of Uppingham and the village is bisected by the busy A47 road.

BELOW The regimented avenue of trees leading past Barnsdale Gardens en route to the main lodge entrance to Exton Park is particularly impressive when the autumn colours have really taken hold. Although the avenue now flanks the road to Cottesmore and the A1, when initially conceived it would have been a long carriage drive designed to impress. For the great landowners of the eighteenth and nineteenth centuries estate labour was plentiful and so creating such an avenue presented few logistical problems, unlike some of the landscaping schemes proposed elsewhere by pre-eminent designers of the period such as Lancelot 'Capability' Brown, who thought nothing of insisting upon the removal of hundreds of tonnes of earth from one site to another in order to create an unnatural impression of natural perfection.

OPPOSITE, CLOCKWISE FROM TOP LEFT Beech nuts, blackberries, sloe berries, haws

OVERLEAF The more spectacular sunsets and rainbows never seem to appear on demand, but usually reserve their finest moments for when one is trapped on the middle lane of a motorway with no exit in sight. On this particular occasion I was exploring the high countryside around Thistleton in the north of Rutland when I realised that there was indeed going to be a spectacular end to the day. I was able to line up a shot that had a good set of silhouetted trees for the sun to sink behind and was not disappointed when the moment came.

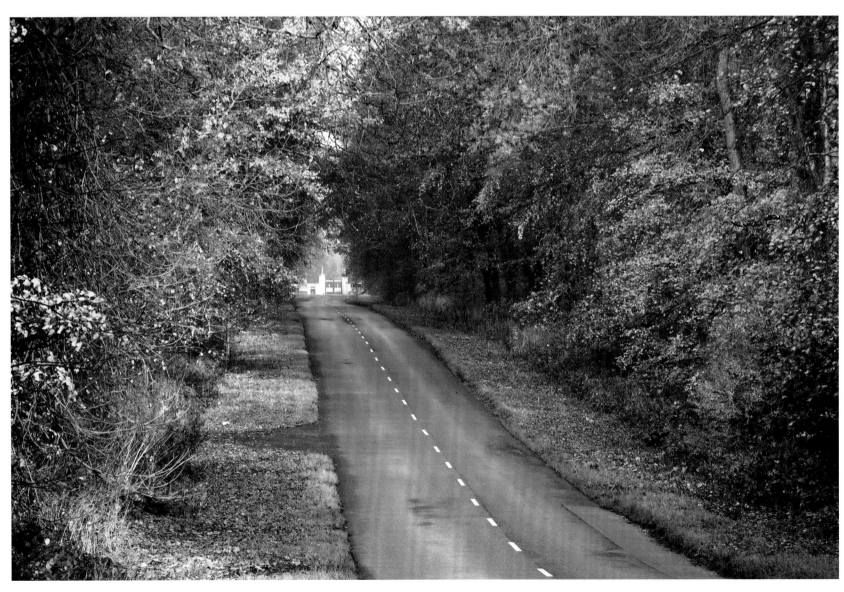

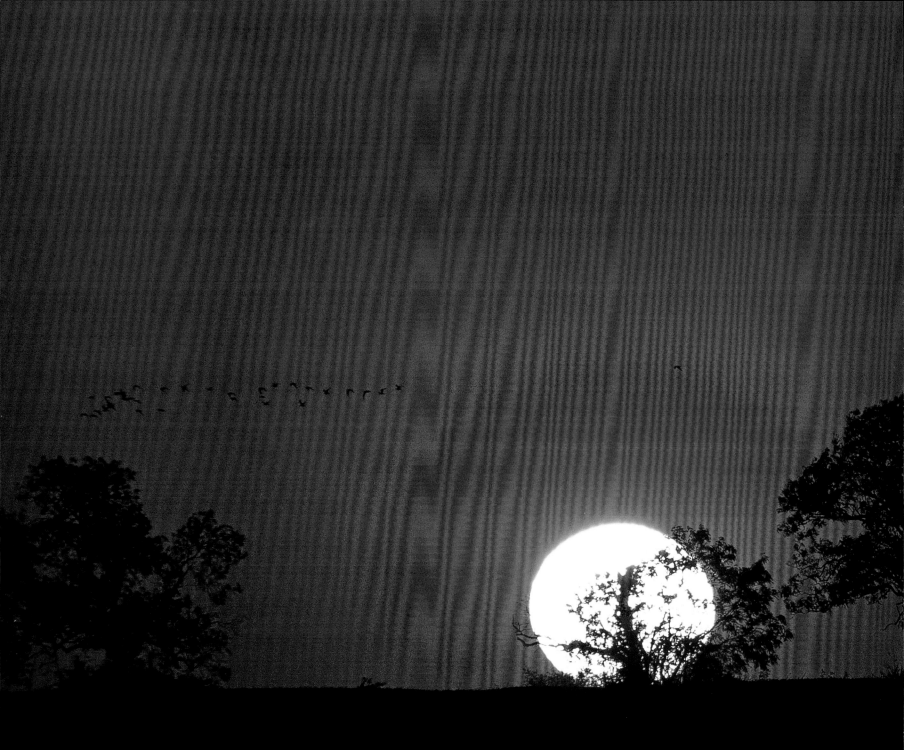

rutland churches

Rutland is arguably the most richly endowed county in England when assessing not only the number of parish churches per square mile, but also their outstanding architectural and historical merit. The level of patronage available and a church's location clearly affected the quality of finish and the raw material from which it was fashioned. Many of England's finest churches are located either above, or near to, the limestone belt and Rutland was able to meet both those essential criteria of ready access to high quality building stone and wealthy landowners. Clipsham Quarry in the east of the county has been providing stone for both the county's own churches and other historic buildings further afield for centuries. It goes without saying that not every Rutland church was built on a grand scale and the county also has its fair share of comparatively humble places of worship but they do tend to be overshadowed by their more illustrious neighbours. The endowment of a substantial parish church was considered not merely a status symbol to impress the living but was also viewed as a sound investment for the life to come.

The walls of most medieval churches were covered in paintings proclaiming messages of hope and doom with the emphasis being heavily weighted towards the latter. Whilst the murals were ostensibly for the benefit of a predominately illiterate congregation, even the more educated landowning classes would not have been immune from observing in graphic detail the dire consequences of sin, especially as it was they who probably had greater opportunities to blot their earthly copybooks! When those who had funded the building of the churches departed this life to discover whether or not it had been a sound wager, they left significant reminders of their presence on earth through the medium of some glorious memorials. Rutland is rich in funerary architecture and the church at Exton is famed for its monuments to entire dynasties spanning several centuries.

During the period from the end of the twelfth century to the end of the fifteenth century England (and Rutland) witnessed the construction of an unprecedented number of churches ranging from the Romanesque style introduced by the Normans through to the three phases of Gothic architecture; Early English, Decorated and Perpendicular. However, few churches in Rutland can boast a pure architectural pedigree from just one of those periods and most are hybrids with attributes from some, or all, of the architectural progressions.

Churches such as those at Tixover, Morcott and Essendine retain substantial Norman features and although Tickencote is regarded as the most complete surviving example from the Norman period, only its superb chancel arch is original with the lavishly decorated exterior being a nineteenth century Romanesque pastiche.

Imposing towers, spires and elaborate window tracery are particular features of the Early English and Decorated periods and one could single out Ketton, Langham, Oakham, Empingham and Whissendine as being particularly fine examples. The final Perpendicular phase of the Gothic style is less well represented, with Lyddington being virtually the sole standard bearer. Regardless of what architectural merits Rutland's parish churches may possess, the single greatest factor that unites them all is that so many are open to visitors as a matter of course. We should be extremely grateful that those in charge of these precious historical monuments and places of worship have sufficient faith in human nature to allow unfettered access during daylight hours.

Tickencote is renowned for its late twelfth century chancel arch, whose lavishly carved six orders are a magnificent celebration of Norman church decoration and one of the finest examples of the genre in England. The masons used combinations of the typical decorative features of that period to create dramatic bands of geometric and chevron designs, foliage, animal and grotesque heads. The passage of time and gradual settlement have taken their toll on the arch's perfect symmetry but when one considers that the church was rescued from serious dilapidation and virtually rebuilt during the late eighteenth century, it is actually not faring too badly! The restoration was carried out in 1792 at the behest of Miss Eliza Wingfield, (a member of one of Rutland's prominent landowning families) to plans drawn up by the delightfully named architect Samuel Pepys Cockerell (1754–1827). The arch was the only part of St Peter's not dismantled during the rebuilding and the church seems to have been constructed around it. The chancel was reassembled in its original form using most of the existing materials but the nave fared less well and appears rather bland by comparison. Despite being located perilously close to the busy A1, both church and much of the village lie at the foot of a steep incline and are protected to some degree from the incessant noise of passing traffic. Consequently, the aura of tranquillity that has enveloped the churchyard and immediate environs of St Peter's for over 800 years remains more or less intact.

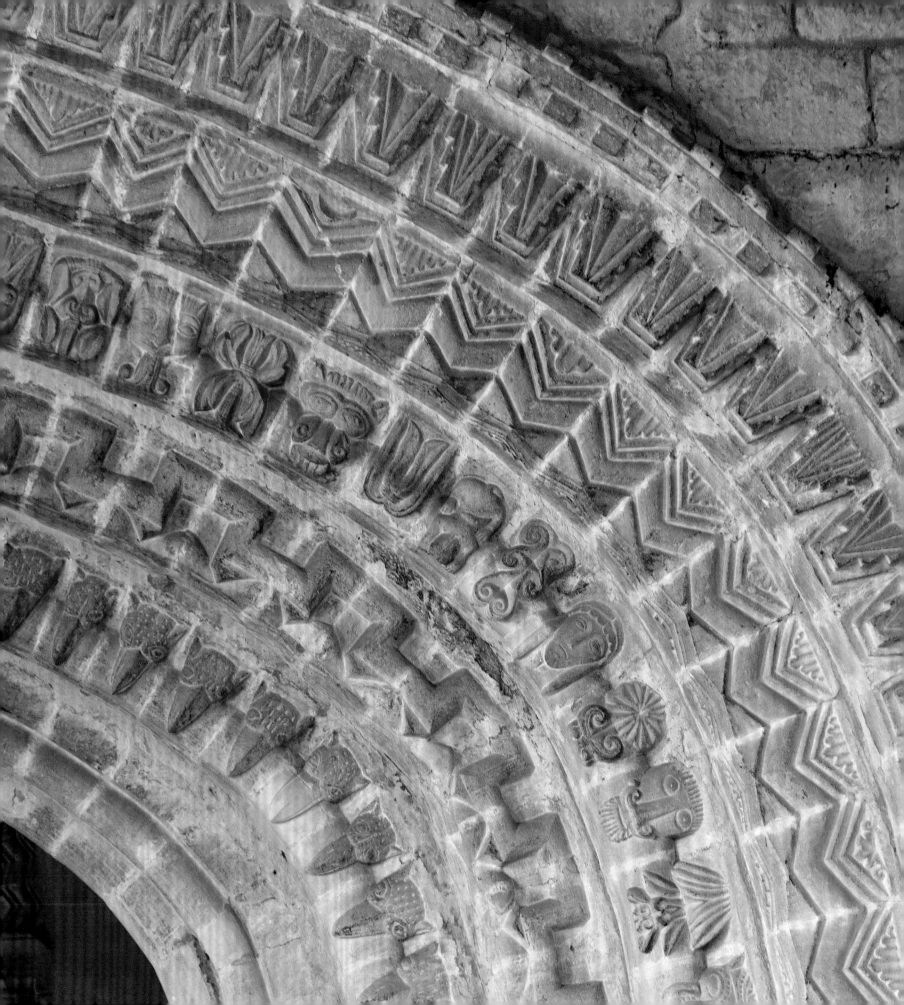

BELOW The elegant spire of All Hallows' rises high above the stone and thatch cottages of Seaton, a village set high on the hillside overlooking the Welland Valley and the southern boundary of Rutland with Northamptonshire. All Hallows is one of the longest churches in the county and although retaining some particularly fine twelfth century Norman carved detail in the chancel arch and south doorway, it is predominantly of the thirteenth century with some later additions. Despite being somewhat hemmed in by tall yews, the churchyard nevertheless affords fine views of the impressive eighty two arches of the Welland Railway Viaduct, arguably the county's second most famous manmade landmark after Rutland Water. Seaton is also associated with one of Britain's most celebrated names, Sir Henry Royce, joint founder with Charles Rolls of the Rolls Royce car and aero engine business. When created a Baronet for 'services to aviation', Royce chose Seaton as his territorial designation in memory of his family who had once worked a flour-mill in the area.

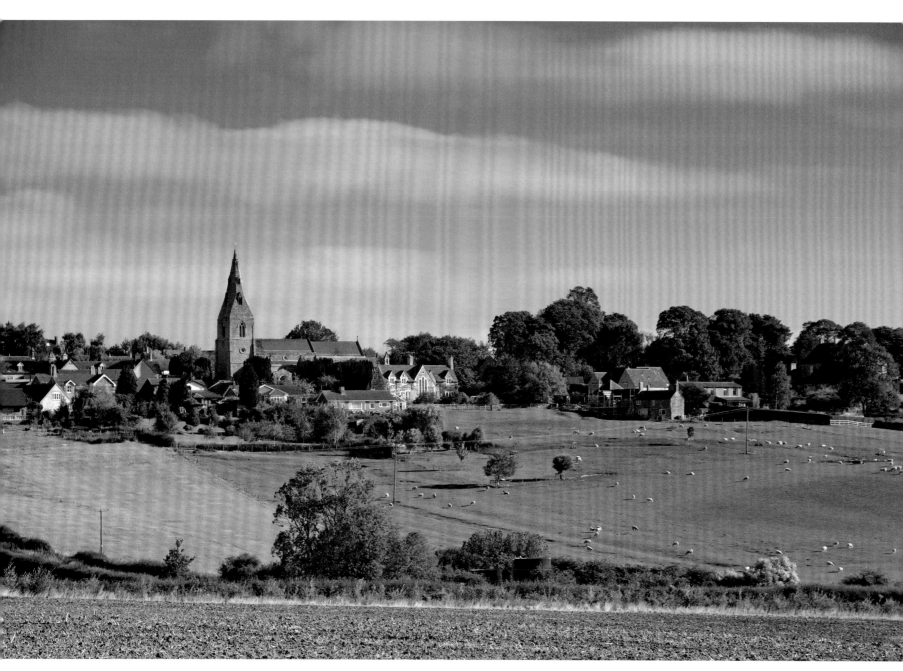

RIGHT This long distance view of St Peter's, Empingham from high ground to the south reveals just how omnipresent and dominating such churches must have seemed to medieval communities. Empingham, Exton and Ketton are a trio of adjacent villages all boasting outstanding churches but only St Peter's can be viewed and fully appreciated in the context of its landscape and village setting. Exton is set well apart from its community and Ketton so hemmed in by other buildings it is impossible to get any kind of overview. Empingham's fourteeth century tower and crocketed spire were later additions during the Decorated period and although the church was given new windows, a clerestory and new roofs during the following century, most of St Peter's interior was constructed in the Early English style. That first of the three phases of Gothic architecture is typified by its clean lines and most elegantly styled arches that have an enduring purity of form often lost in the complexities of design and decoration that followed later.

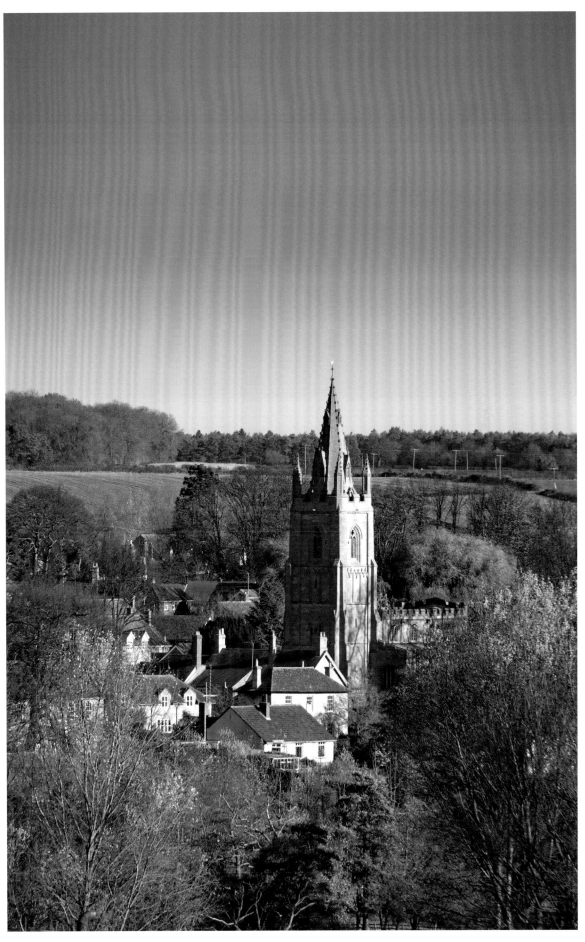

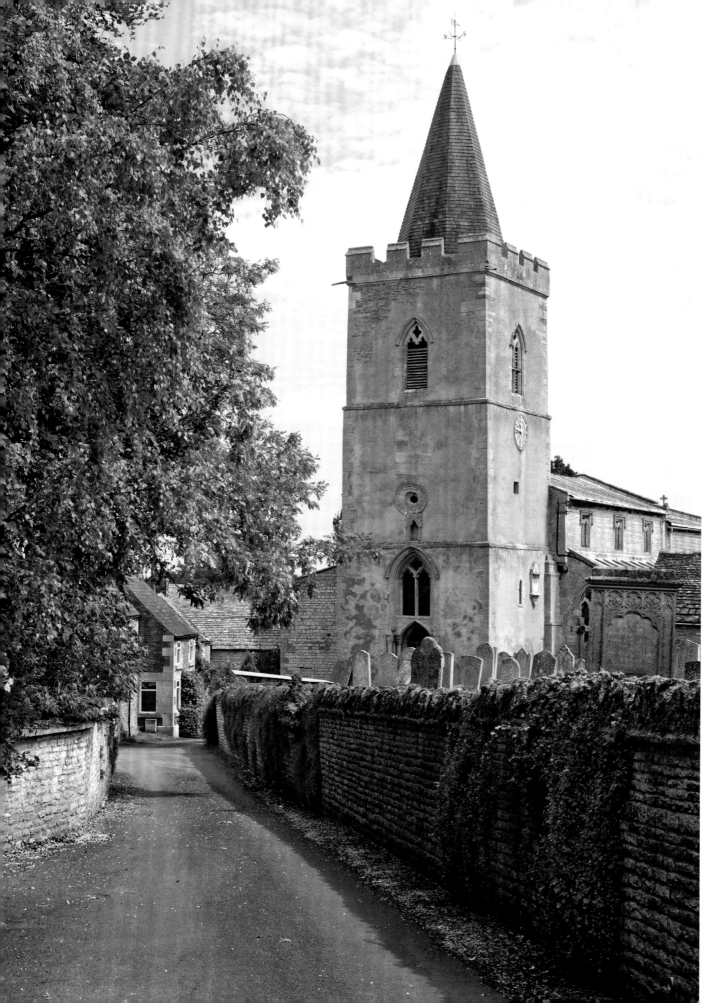

LEFT St Mary the Virgin and its churchyard occupy an elevated, walled site in the very heart of Morcott, neatly encompassed by the stone buildings of Church and School Lanes. Few other parish churches in Rutland can boast such an idyllic village setting. Although the core of this Grade I listed building dates back to the eleventh century, most of the notable architectural features are from the Norman period of the following century. The arches and richly carved capitals of both the north arcade and tower survive in their original form and although there were later additions and modifications to the church's interior and windows, the overriding impression is of a typically atmospheric Norman church. That richly endowed ensemble is further enhanced by important individual detail, not least the rare 'pancake' window located on the second tier of the twelfth century tower, probably designed to give light and air to the belfry. Fortunately, the inevitable Victorian 'restoration' that took place in 1874 was conducted with a refreshingly light touch.

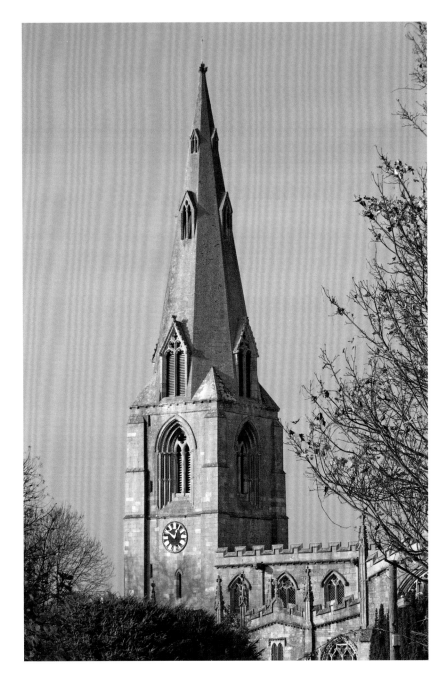

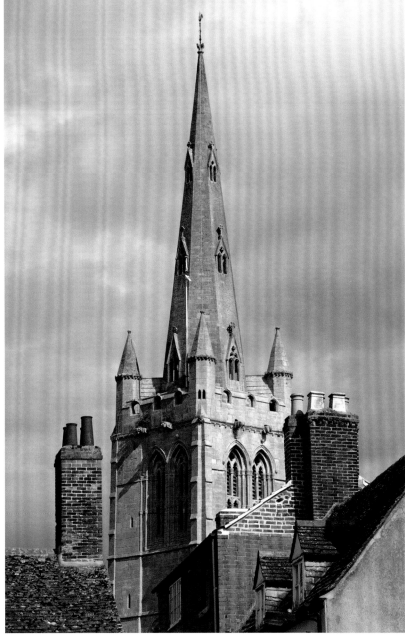

ABOVE Langham lies near Rutland's north-west border with Leicestershire on the main road linking Oakham with Melton Mowbray and although the village has evolved into something of a hotchpotch of architectural periods and styles, at its heart stands one of Rutland's most noble churches. The tower and chancel belong to the thirteenth century but the remainder, including a magnificent spire, are from the fourteenth century Decorated period. The spire has extremely intricate details featured on the three tiers of gabled lights adorning each of its main faces. Langham has a particularly noteworthy ecclesiastical connection, having been the birthplace of Simon Langham (1310–76), who was elected Archbishop of Canterbury between 1366–68. From being Abbot of Westminster, he became bishop of Ely, Treasurer and then Chancellor of England. Upon receiving a cardinal's hat from Pope Urban V, Langham chose to relinquish his post at Canterbury in favour of the Papal Court in Avignon.

ABOVE The noble limestone spire of Oakham's parish church soars high above the cobbled market square as an enduring reminder of the town's affluent past. A twelfth century Norman church that existed on the site was replaced during the following century with the chancel arch, south doorway and porch from that period surviving through the later periods of rebuilding. The fourteenth century Decorated style is well represented by the tall, slender columns of the nave and whose capitals are intricately carved with animals, foliage and key moments from both Old and New Testaments. The church was later subjected to the common fifteenth century practice of raising roof levels and introducing a clerestory, resulting in the addition of some excellent Perpendicular style windows. One of the church's greatest treasures is an early thirteenth century bible in Latin inscribed on vellum and believed to have been created in the decade preceding the Magna Carta of 1215.

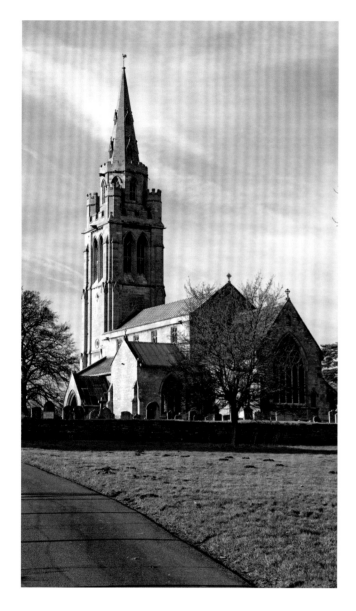

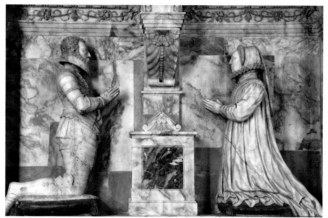

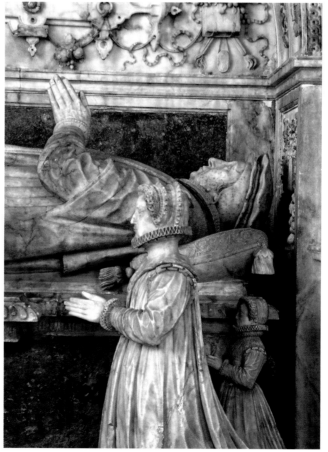

ABOVE Church hunters in pursuit of Exton's parish church will draw a blank if searching around the village green and its immediate environs because St Peter and St Paul's is hidden away at the end of a narrow lane leading up into Exton Park. First impressions are that this imposing structure must surely be of Victorian origin and it certainly resembles the kind of church one might encounter in the heart of a prosperous English town once possessed of generous benefactors. The original church was predominately thirteenth and fourteenth century but suffered catastrophic damage when the spire was struck by lightening during a violent storm in April 1843 and was consequently rebuilt by Victorian architects. The collapsed tower resulted in stones being scattered far and wide into a confusing masonry jigsaw and although some pieces were slotted into their appropriate chronological places, many were discarded in favour of new material. However, regardless of how the task was accomplished, the rebuilt version is a joy to behold but for many visitors, the main attraction lies within as Exton is famed for its outstanding collection of sixteenth to eighteenth century monuments to the Harrington and Noel families associated with Exton Hall.

A late twentieth century survey of the monuments revealed some to be in a perilous state and a restoration fund was immediately set up to save them. The work was expensive but essential to preserve monuments of national importance, not least the outstanding memorial to Baptist, Viscount Campden sculpted by the legendary wood carver, Grinling Gibbons (1648–1721). His work adorns royal palaces, cathedrals and stately homes but although Gibbons executed very few works in marble, the Campden memorial provides ample proof that he was not at all inconvenienced by working in a different medium. The monument contains some twenty-five figures, the two most prominent being the Viscount and his fourth wife, Elizabeth; the rest of the cast being his previous three wives and assorted children. Employing a craftsman of Gibbons' stature carried a hefty premium and commissioning the monument cost £1,000, a sum that translates from late seventeenth century values into a modern day sum well in excess of £80,000!

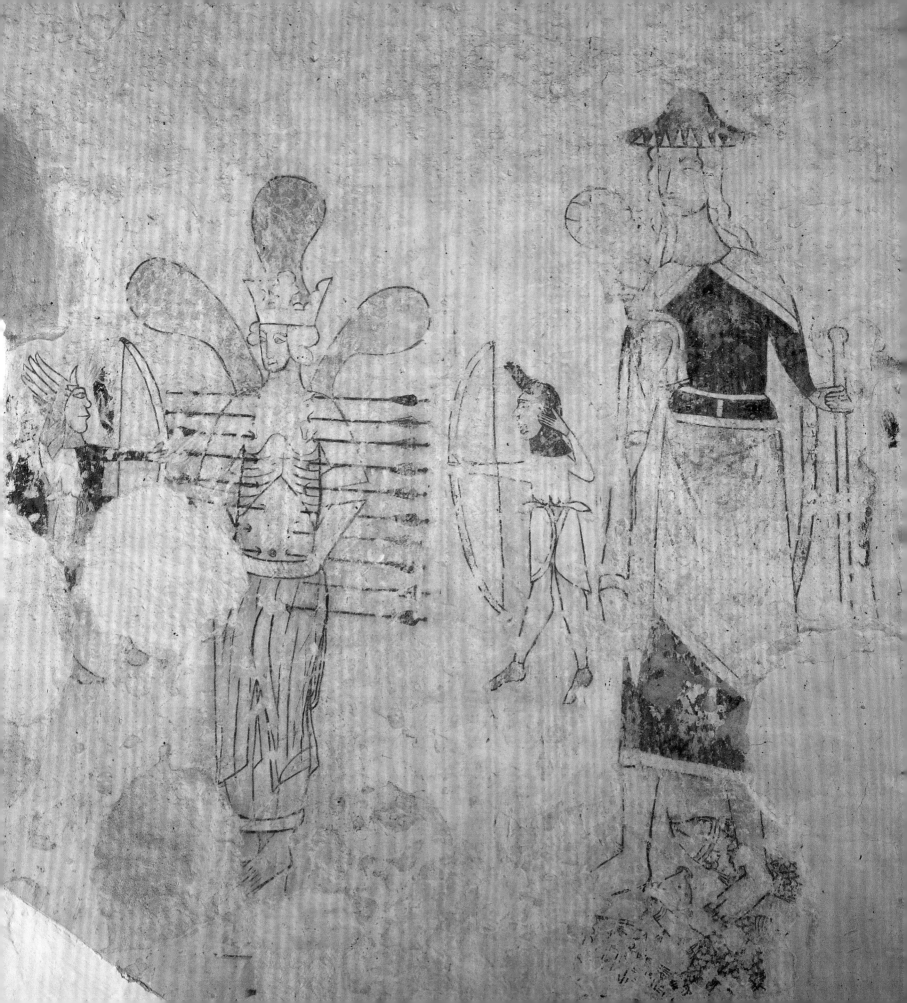

LEFT The fragments of medieval wall paintings that survived the Reformation's wholesale whitewashing provide an invaluable insight into what church interiors might have looked like. Alternating illustrative messages of hope and doom were interspersed with depictions of notable passages or parables from the Bible or important saints and Christian martyrs. This outstanding thirteenth century panel on the south wall of Stoke Dry's Digby chantry chapel depicts St Christopher carrying the child Jesus upon his shoulders and the martyred King of East Anglia, St Edmund, being shot with arrows fired by Danish archers whilst tied to a tree. The Digby family made Stoke Dry their principle seat from the fifteenth to seventeenth centuries but although their house has long since disappeared, they are remembered by the splendid alabaster table tomb to Kenelme Digby (died 1590), his wife and eleven children, two of whom died in infancy.

RIGHT AND BELOW Rutland's churchyards are renowned for their carved tombs and headstones and the memorials surrounding the church of St Andrew, Lyddington are particularly good examples. The fine texture of the Rutland limestone gave stonemasons the artistic freedom to indulge in complex scrollwork, other embellishments and perfectly carved lettering. The church itself is mostly from the final Perpendicular stage of the Gothic period (late fourteenth to early sixteenth century) and one of the key differences between that and the preceding Decorated era is in window design. Florid swirls and intricacies in the stonework were replaced by narrower mullions to create much larger windows. This allowed the glaziers to either flood a church with light or create vast transparent canvases of religious art through the medium of stained glass. Gargoyles and grotesques are a feature of many English parish churches, introducing a chilling and disconcerting hint of the underworld into an otherwise serene environment.

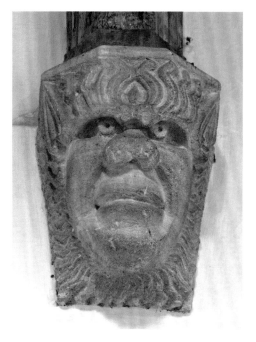

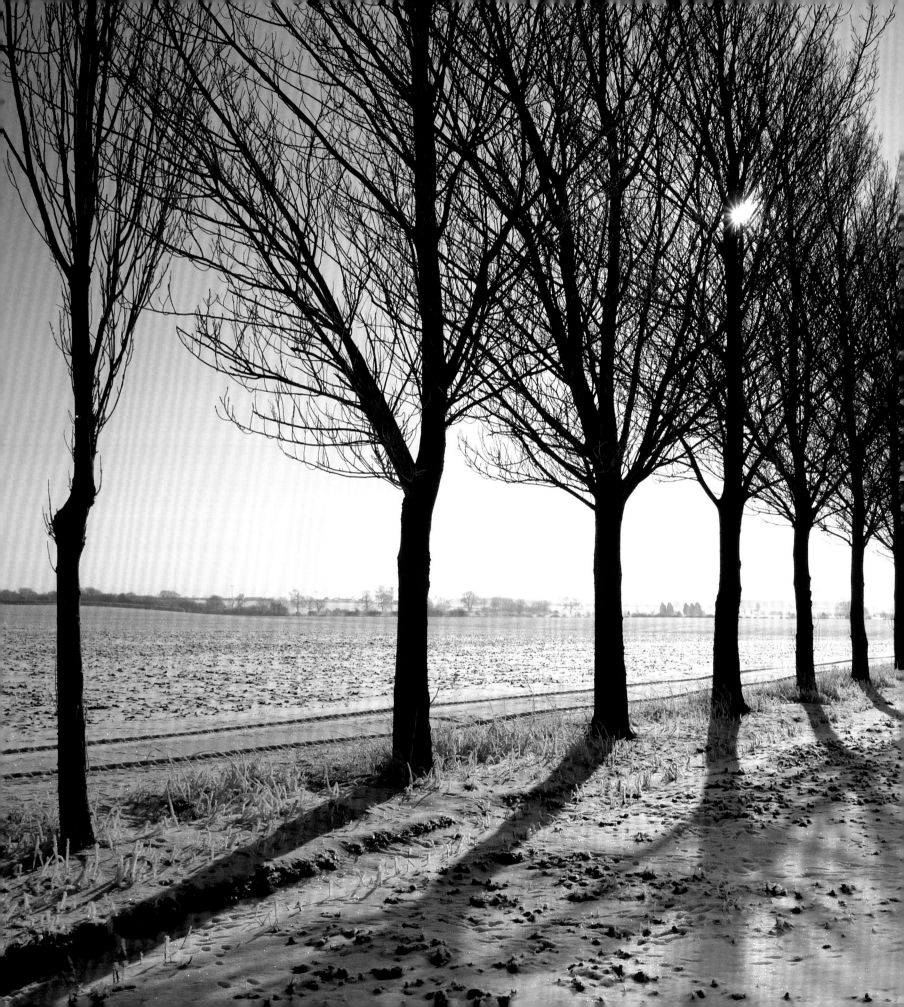

winter

Winter has become such a movable feast in recent years, seemingly alternating between Arctic and Mediterranean climates, that it must be a nightmare for those who work the land to make the right choices and predictions for animal husbandry and crop management; always hoping for the best but fearing the worst! Rutland may be in the heart of England, but it is nevertheless subject to its fair share of adverse conditions. During the shortest months of December, January and February, days of constant cloud cover and rain can soon reduce fields and footpaths to soggy, boot-caking quagmires of glutinous mud. Conversely, the enigma that is the British climate can produce crisp days when the sun is bright, but never seems to move far above the horizon and its acutely angled light illuminates every detail and texture of the landscape with startling clarity.

In a world where wildlife habitats are increasingly under threat, Rutland Water plays a vital role as a nature reserve, offering a temporary safe haven to migratory birds on their annual commute from one part of the globe to another. One group that will not be over-wintering on Rutland Water are the much treasured Ospreys, who spend their winter months fishing off the African coast. When autumn foliage has finally succumbed to the inevitable and nature's camouflage is stripped away from the woods and hedgerows, the countless exposed holes used by woodpeckers, rabbits, foxes and badgers confirm a thriving wildlife population in many parts of the county. However, by the time December rolls along, nature has already slipped into a well-rehearsed state of suspended animation, waiting patiently for the first snowdrops to give the all clear so that another year can get under way.

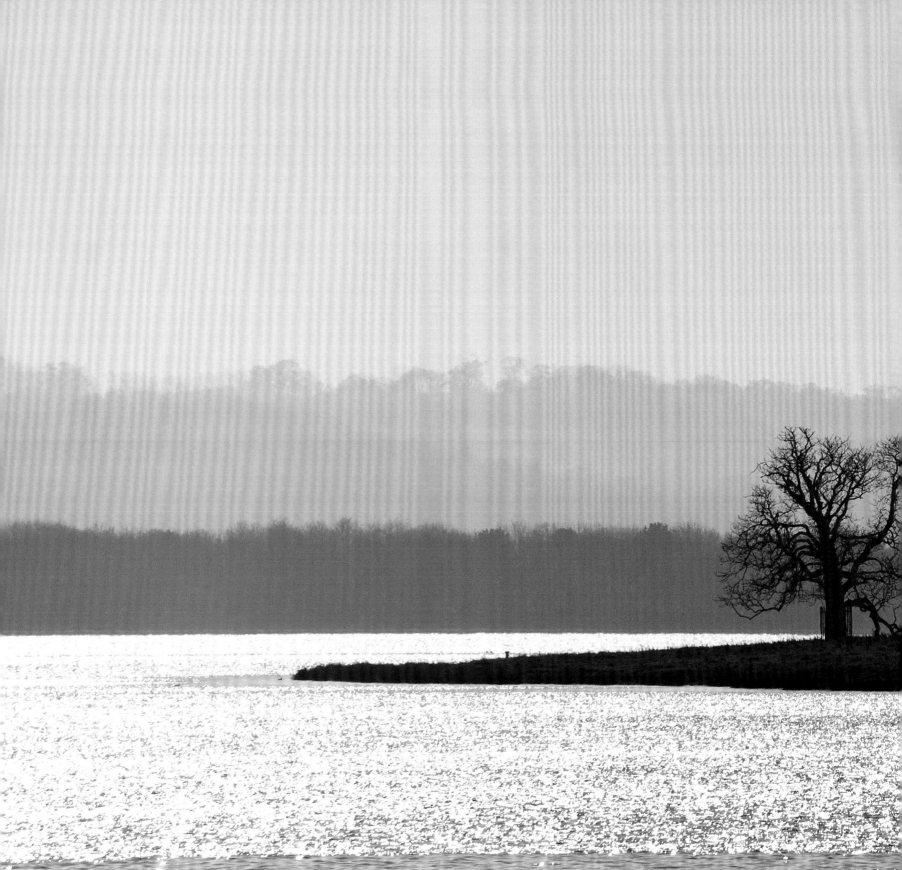

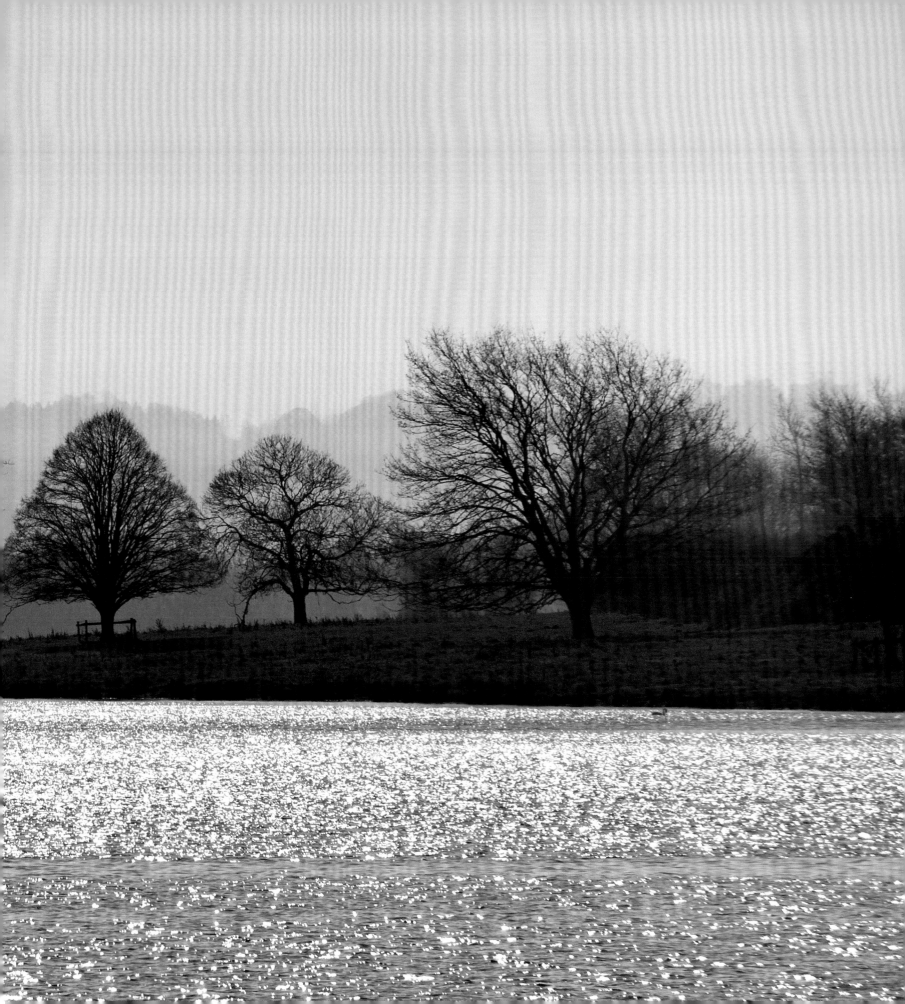

BELOW Clipsham Quarry takes its name from the village lying close to Rutland's eastern border with Lincolnshire. It is renowned for producing a particularly durable pale coloured limestone and traces of Roman workings have been discovered in one of the older parts of the quarry. The stone the Romans extracted was used in the construction of villas set close by the route of Ermine Street, the great Roman road connecting London with Lincoln. The quarry boasts an impressive list of buildings on its curriculum vitae, the earliest recorded example being the reconstruction of parts of Windsor Castle between 1363–68 and also in the twentieth century when Clipsham stone was used in the restoration of St George's Chapel within the royal castle. The architect, Sir Thomas Jackson, introduced the quarry's stone to Oxford during the 1870s to build the Examination Schools and several colleges also had buildings dressed with Clipsham limestone.

BELOW This part of Clipsham Quarry, currently in operation, clearly illustrates the mighty band of limestone lying just a few metres beneath the topsoil. Clipsham is just one segment of the vast arc of limestone running from Yorkshire to the south coast and although its depth below the surface varies from county to county it remains a comparatively accessible resource. The stone here is nearly always extracted with drills and mechanical buckets rather than being blasted with gunpowder and it is astounding to note that despite demand from many other quarters, Clipsham Quarry also manages to supply over one thousand tonnes of block limestone a year for the restoration of England's churches and cathedrals. Many of our English cathedrals have ongoing programmes of restoration to preserve their increasingly fragile, centuries-old stonework and it is refreshing to note that in addition to the continuity of supply of native stone, highly skilled twenty first-century masons are emulating the stone carving and sculpting techniques used by their medieval predecessors to ensure a seamless transition from old to new.

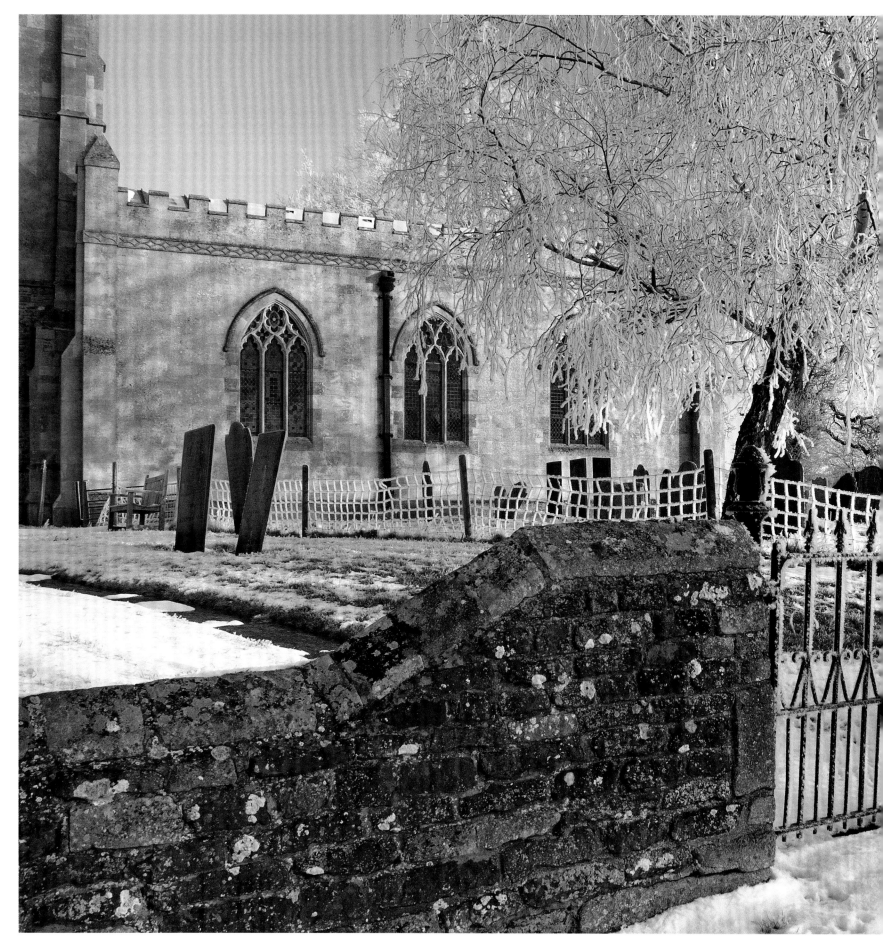

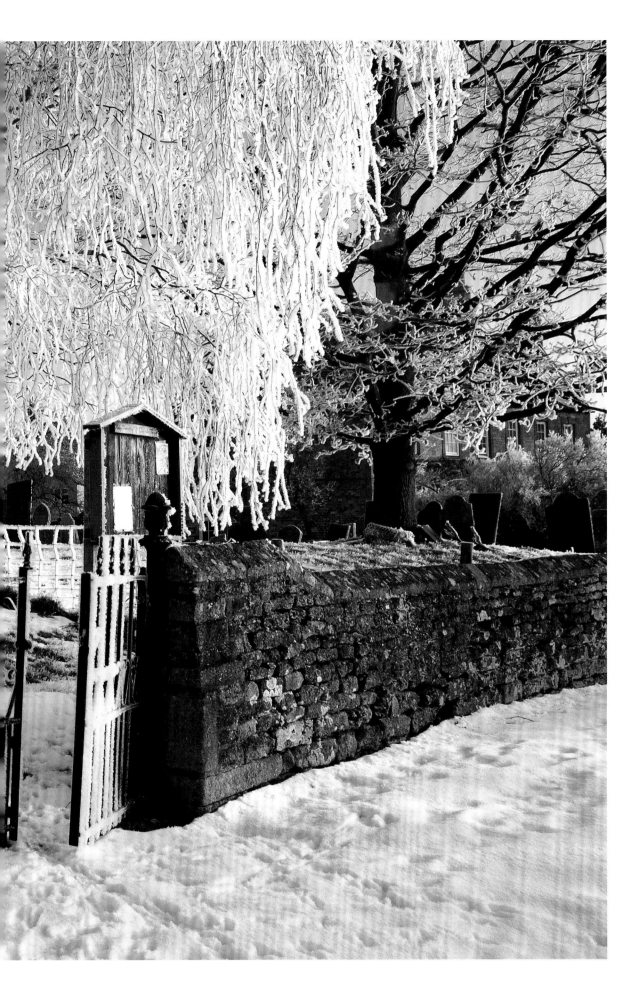

LEFT Teigh is a tiny village lying close to Rutland's northern border with Leicestershire. On this crisp winter morning when the temperature registered minus15 degrees Celsius, it felt more like the Russian Steppes, but the thick hoar frost draped over the trees created a scene of unparalleled beauty. Most English communities have some form of war memorial to those who died in the Great War, be it in the heart of the village or in the parish churchyard but no such structure exists here. Teigh is one of the country's few 'Thankful' villages, a term referring to the fact that none of its residents perished in the Great War. This fact is celebrated in a simple brass plaque within Holy Trinty church, stating that the eleven men and two women who went to France all returned alive.

OVERLEAF The Clipsham Yews originally formed the carriage drive to Clipsham Hall and are now acknowledged as one of the finest collections of topiary in England. Most of the trees are well over 200 years old and the half-mile long avenue is now in the care of the Forestry Commission and open to the public. It is the Commission's specially trained gardeners who have the unenviable task of executing the annual clipping. Anyone who has struggled to tame their own hedges will certainly empathise, but Clipsham is hedge trimming taken to a significantly higher level. The avenue still contains the customary animal depictions and geometric designs but in recent years it has also become the custom to carve the dates of significant royal anniversaries and other landmark dates on the main body of some trees.

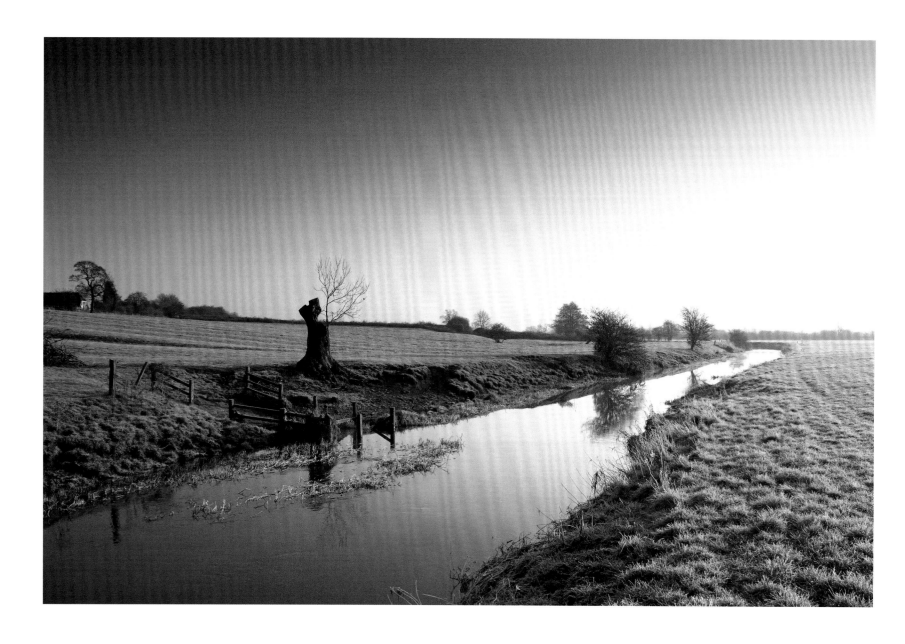

ABOVE The River Welland near Caldecott on the south western tip of Rutland forms the majority of the county's southern border with Northamptonshire as it twists and wriggles its way eastwards to the Wash. Despite not being the most powerful of rivers, its waters were regularly harnessed to drive many mills along its length with Caldecott's water mill grinding its last corn in 1910.

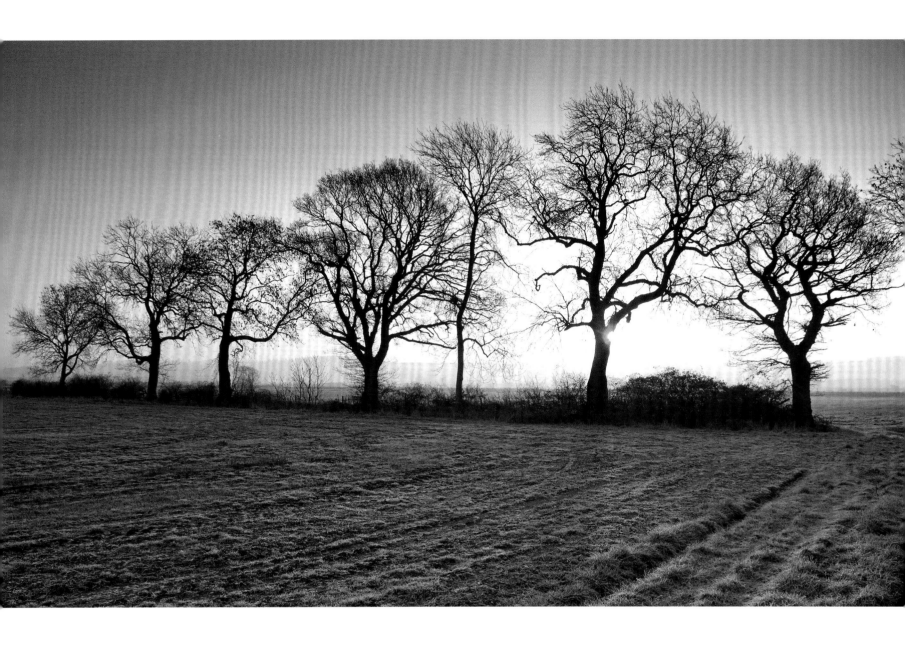

ABOVE Winter sunrise at
Caldecott looking across the
Northamptonshire border
towards Rockinhgam Castle
and Corby. Fields already
planted with crops lie in
suspended animation until the
ground thaws and the annual
cycle of growth and harvest
can continue for another year.

OVERLEAF The parkland flanking
Barnsdale Hall Hotel lies on
the north shore of Rutland
Water to the east of Oakham.
The hotel was created from
a late nineteenth century
hunting lodge built for the 6th
Earl Fitzwilliam in the very
heart of some of England's
finest hunting country. The
open, undulating landscape of
Rutland is still loved by horse
riders, although legendary
local hunts such as the Belvoir,

Cottesmore and Quorn are now
legally restricted to galloping
across country in pursuit of
a trailed scent, rather than
a fleeing fox. For those who
would like to feel the breeze on
their faces on a different kind
of mount, a surfaced 23-mile-
long cycle route completely
encircles Rutland Water.

index